Amy Evans
and Evan Joseph

Literary
NEW YORK
Landscapes

A book-lover's tour of the
city that never sleeps

PAVILION

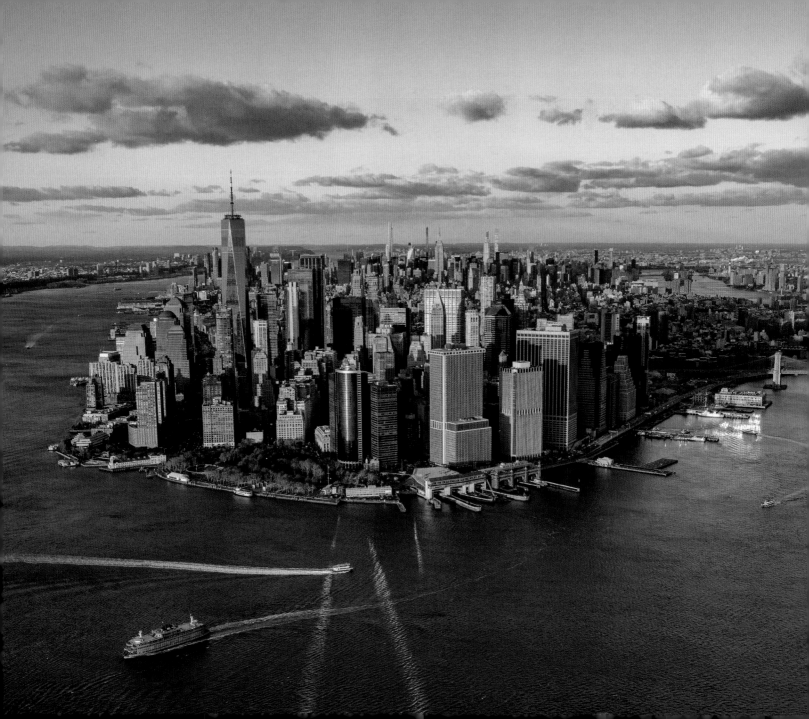

CONTENTS

LEFT New York City at golden hour, as photographed from a helicopter over the harbour.

FOREWORD

A LITERARY JOURNEY THROUGH NEW YORK

Most people who met me as a child remember me with my nose stuck in a book. Most people who met Evan Joseph remember him with a camera in front of his face. Many of the same people have met us both and can attest that doing this book together is a dream come true for us, and one we've been working towards for many years.

Evan and I grew up in Baltimore, met and fell in love in Los Angeles, and started working together and got married in New York. In every corner of NYC, between the skyscrapers that touch the clouds and the cobblestone streets that keep secrets in their uneven nooks, there exists a narrative woven, not just of stone and steel, but of words and pixels, of two unique perspectives that show off the city perfectly – on their own, and even better together. It is a narrative of romance, artistry, and entrepreneurship, which, for us, spans decades, but for the city at large, spans generations. The pressures and opportunities created by living side by side with more than eight million other people creates a collective of artists and art that would not be possible anywhere else in the world.

This book is a love letter to that narrative – a testament to the countless haunts, hideaways, and hangouts that have shaped the literary landscape of New York.

Our own NYC story starts at the very beginning of the new millennium. We lived in SoHo on Thompson Street, in a third-floor walk-up, in a neighbourhood booming with art galleries, boutiques, parks, and dozens of technology companies looking to cash in on emerging internet technology. We started an interactive entertainment company to bring stories, pictures, and games to the internet and mobile phones. This was the year 2000, early days for digital content creation, and we obsessed over every word and pixel in a little office on Broadway and Bleecker near New York University (NYU).

As our company flourished, so too did our appreciation for the literary landmarks you'll find on the following pages. We met new friends under the arch in Washington Square Park, where the words of Walt Whitman and Mark Twain seemed to whisper in the breeze. Inspiration struck in the bustling bookstores of Greenwich Village, including the never-ending Strand Bookstore and the mysterious Alabaster Bookshop, where we picked up budget paperbacks to squirrel away in our twenty eight square-metre- (300 square-foot-) apartment, where over-crowded bookshelves already lined every available inch of wall space.

In those days, we went uptown only for weekly outings to Pug Hill in Central Park, strolling the literary walk en route and rubbing the Alice in Wonderland statue for luck. We spent almost all of our time downtown, counting many nights out at the Minetta Tavern, Chumley's, McSorley's Old Ale House, and White Horse Tavern, where the rebel spirits of beat poets like Dylan Thomas and E.E. Cummings still swirled in the dim light and loud conversations.

Our journey, however, was not without its challenges. The events of September 11 2001 shook not just the city's skyline but the very foundations of our lives. Half of our building in Tribeca collapsed when the Twin Towers came down, just weeks before our wedding. In the

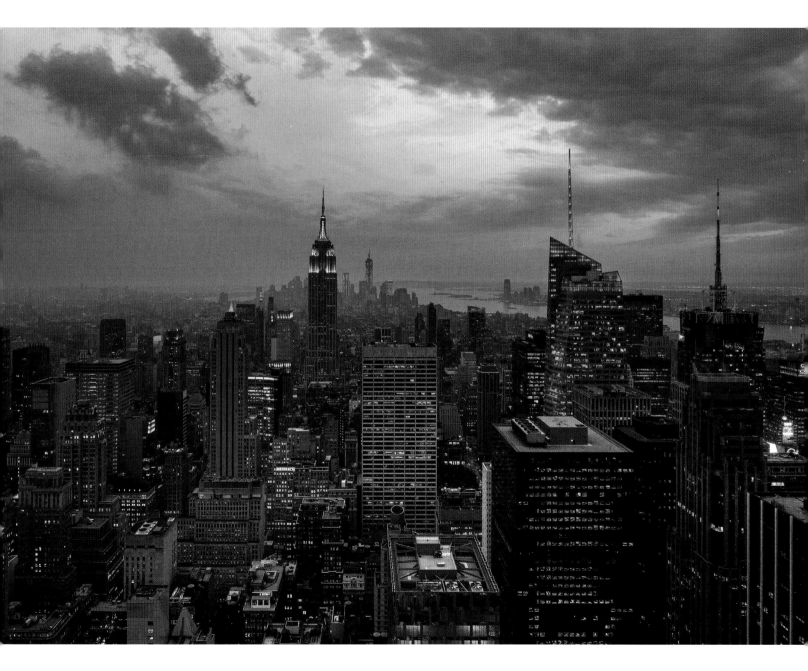

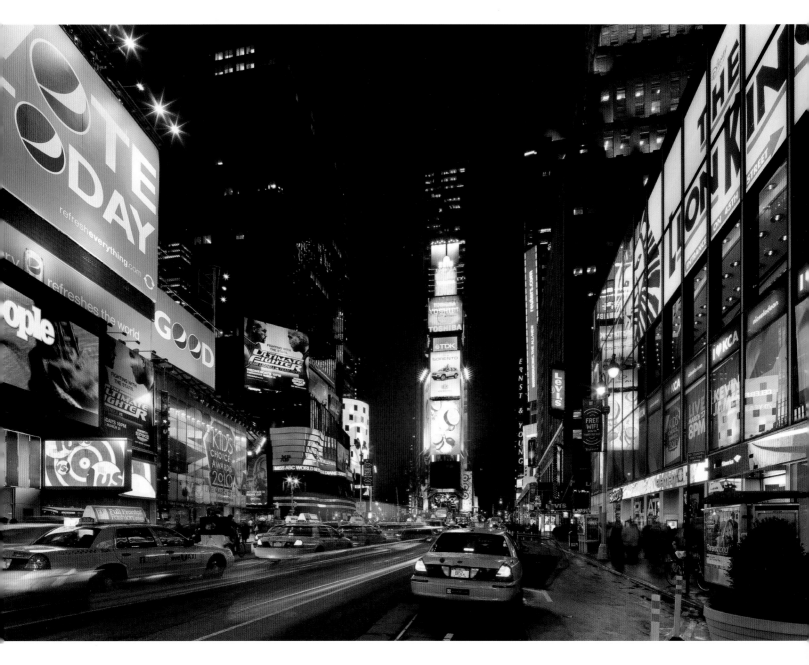

face of tragedy, we discovered a resilience that mirrored the city's own indomitable spirit. So we moved – not just our office, but our home too – to the very bottom of Manhattan, where we found comfort in walking the cobblestone streets near Delmonico's, following the path along the East River and over the Brooklyn Bridge.

This move of less than a mile brought a chance to see the world anew through our respective lenses – mine of words, Evan's of light and shadow. Evan began to catalogue every inch of the city with his camera, learning exactly when the light would be best on any given block at any time of day or year. His work drew the attention of international brands, book publishers, real estate developers, luxury hotels, and celebrities, who commissioned him to show off the phoenix city rising anew.

The literary world of New York became my classroom. I devoured the works of Don DeLillo, whose novel *Underworld* captured the city's post-9/11 zeitgeist with uncanny precision. Jay McInerney's tales of uptown excess and downtown grit resonated with my own experiences of a city divided and united by its many contradictions. We rushed back to The Odeon, a favourite restaurant, as soon as it reopened in those first blocks around Ground Zero. In the pages of these authors' books and countless others, I found reflections of our own struggles and triumphs, and followed the siren's call away from interactive media and towards more traditional storytelling, writing non-fiction for various online publications, and penning books that allowed me to fictionalize facts to make some sense in our newly fractured world.

As our family grew, we watched our children discover the magic of the city that had shaped our lives. Through their eyes, we rediscovered the wonder of New York – the majesty of Brooklyn Bridge at sunset, the kaleidoscope of cultures in Queens, the timeless charm of Central Park's story time by the Hans Christian Andersen statue, and the boats on Conservatory Pond where where the fictional mouse Stuart Little won his boat race. Our children's curiosity and joy reminded us why we fell in love with this city in the first place, renewing our commitment to capturing its essence through our art.

Our New York is a city of contrasts and contradictions, where gritty reality coexists with soaring dreams. It's a place where a chance encounter can change the course of a life, where creativity flourishes in the most unlikely places, and where the next 'Great American Novel' might be taking shape on a laptop in a crowded subway car.

So, as you begin on this literary journey through the streets of New York, I invite you to walk in our footsteps – to explore the places we've haunted, to discover the stories that have shaped us, and to embrace the magic of this city that never sleeps. In the words of E.B. White, whose love letter to New York in *Here is New York* still resonates today: 'The city is like poetry: it compresses all life, all races and breeds, into a small island and adds music and the accompaniment of internal engines.'

AMY EVANS

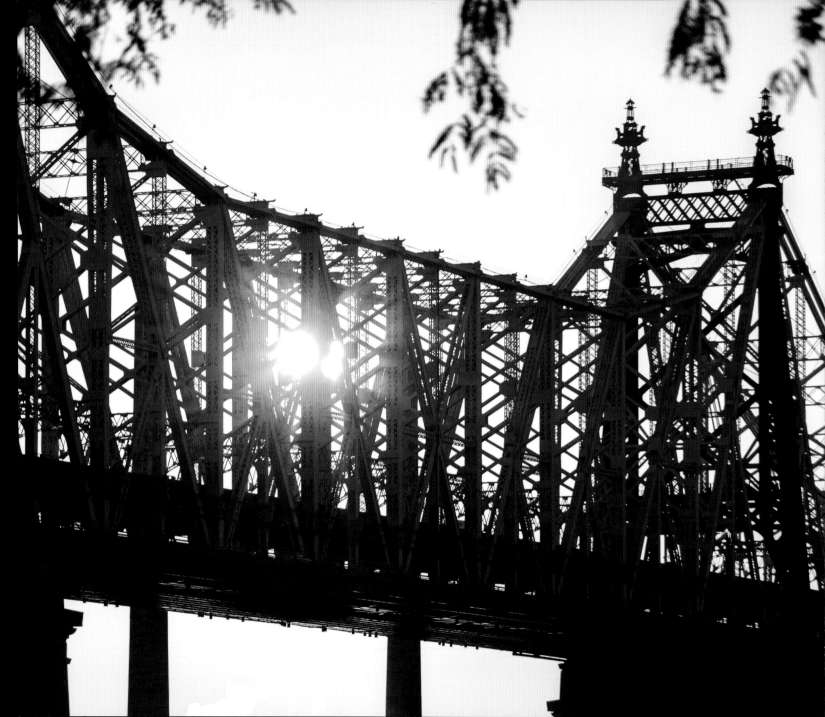

The city is like poetry; it compresses
all life, all races, and breeds, into a
small island and adds music and the
accompaniment of internal engines.

E.B. WHITE

BOOKS

TORES

RIGHT The entrance to Argosy Bookstore. Literature lovers have walked through the site's doors for over a century.

BOTTOM Vintage prints on sale at Argosy Book Store.

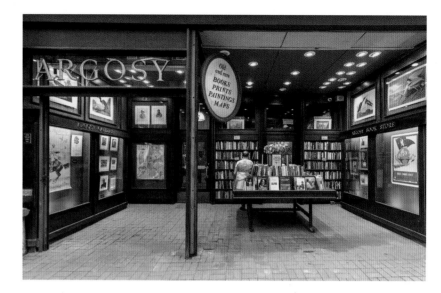

ARGOSY BOOK STORE

116 EAST 59TH STREET

Argosy is the oldest independent bookstore in New York City. It has been owned by the same family since opening in 1925, and - now in its third generation - is run by by sisters Adina Cohen, Judith Lowry, and Naomi Hample. Located between Park Avenue and Lexington Avenue, Argosy specializes in rare and antique books, including first editions, signed copies, and unique literary artefacts. The store has welcomed many famous authors over the years, including Margaret Atwood, Salman Rushdie, Toni Morrison, Gore Vidal, and Joyce Carol Oates, among others. The six floors house an Americana collection, vintage maps and prints, and autographs, in addition to current bestsellers and bargain book bins.

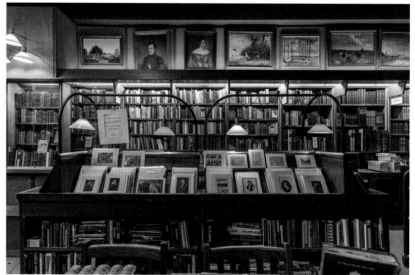

RIGHT The six-storey building is filled with an enormous collection of literary artefacts.

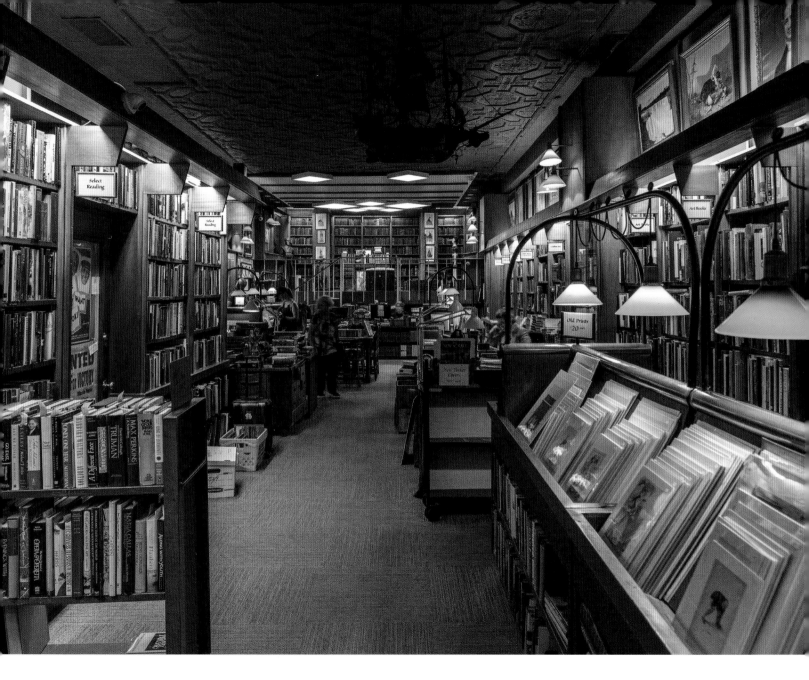

LEFT Three Lives & Company is known for its artistic and carefully curated displays.

BOTTOM LEFT left The entrance on the corner of West 10th Street and Waverly Place.

RIGHT The red doors welcome visitors into the historic Greenwich Village store.

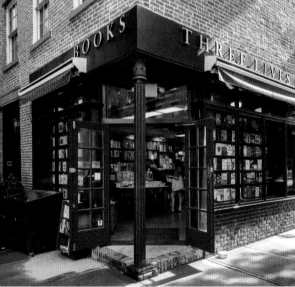

THREE LIVES & COMPANY
154 WEST 10TH STREET

Three Lives & Company has been a West Village literary institution since it opened in 1978. It's a quiet little corner in the city where locals go to talk about books, discover new writers, and get recommendations from the extremely passionate and knowledgeable staff. The bookstore hosts its own unique bestsellers list, and has an extensive catalogue of signed fiction and non-fiction from contemporary and historic authors. Writers including Haruki Murakami, Ta-Nehisi Coates, and Jonathan Franzen have held events at the store.

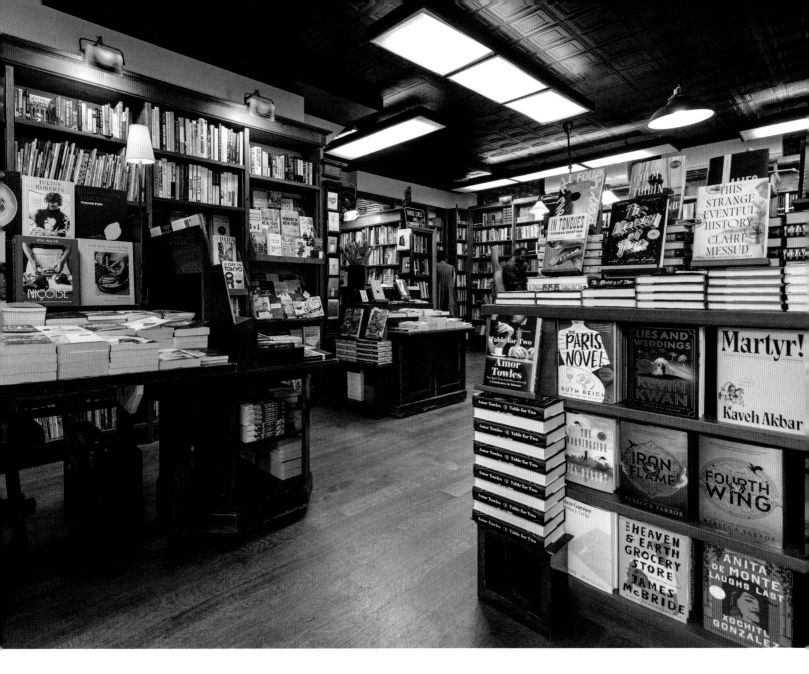

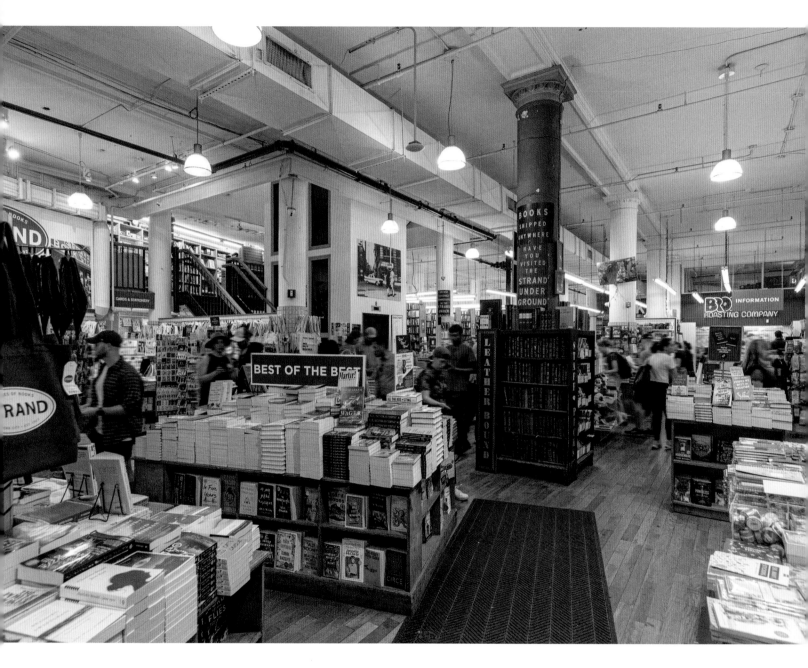

LEFT Named after the famous London street, Strand Bookstore opened in 1927.

RIGHT As well as thirty kilometres (eighteen miles) of books, the store sells an array of literary gifts.

BOTTOM RIGHT Strand Bookstore houses over 2.5 million books.

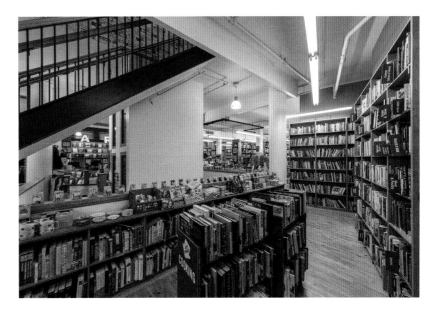

STRAND BOOKSTORE

828 BROADWAY

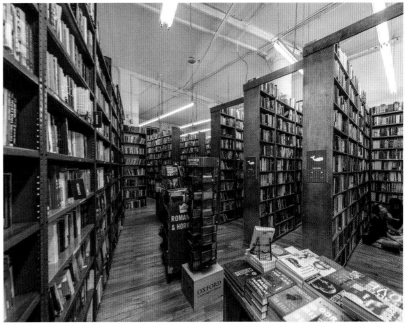

Since 1927, Strand Bookstore has wowed NYC with the thirty kilometres (eighteen miles) of books that fill the shelves of its East Village store. Three generations of the Bass family have curated the collection here and provided customers with unusual ways to purchase books, including book vending machines and 'Books by the Foot', where designers select for colour and size, and not just content. If you visit the Strand, leave time to explore the treasure trove for personal artefacts, notes, and even photographs which can be found hidden among the pages of previously loved books looking for new homes.

RIGHT The attractive bookstore is located on the corner of 93rd Street.

BOTTOM RIGHT The window displays the store's commitment to carrying 'only the best' within all its varied categories.

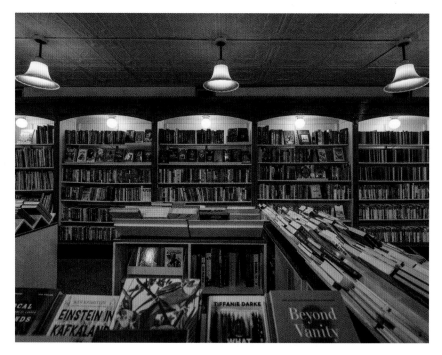

THE CORNER BOOKSTORE

1313 MADISON AVENUE

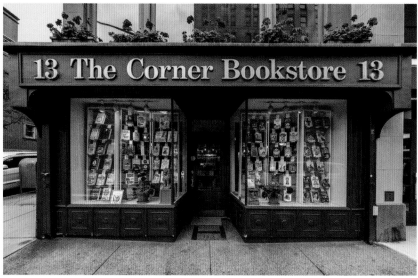

This Upper East Side gem is tucked into a brownstone building full of cosy charm, and was said to inspire Meg Ryan's bookstore in *You've Got Mail*. Although small in size, The Corner is large in influence, offering a curated collection of literature and non-fiction, including a beloved children's section that will send hand-picked gift baskets to new parents. The Corner is a proud participant in neighbourhood events, and hosts weekly affairs where folk can gather, learn, and read together.

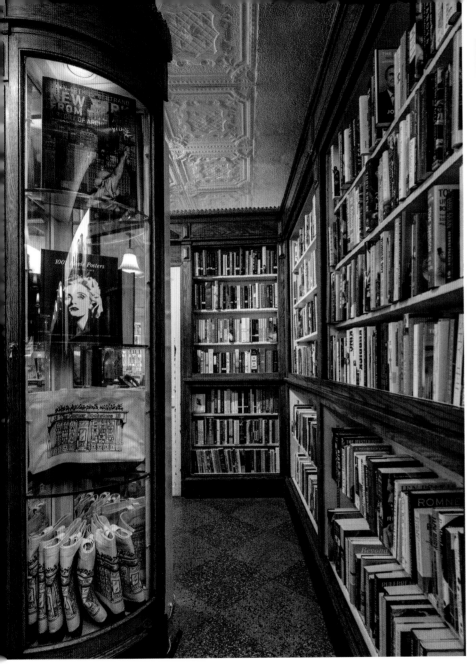

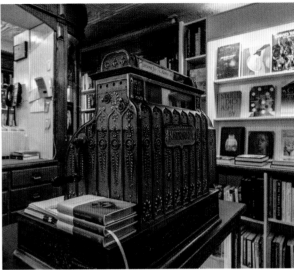

TOP The 100-year-old cash register.

ABOVE The walls are lined with current fiction and non-fiction.

LEFT The historic Carnegie Hill building retains features from its pharmacy days.

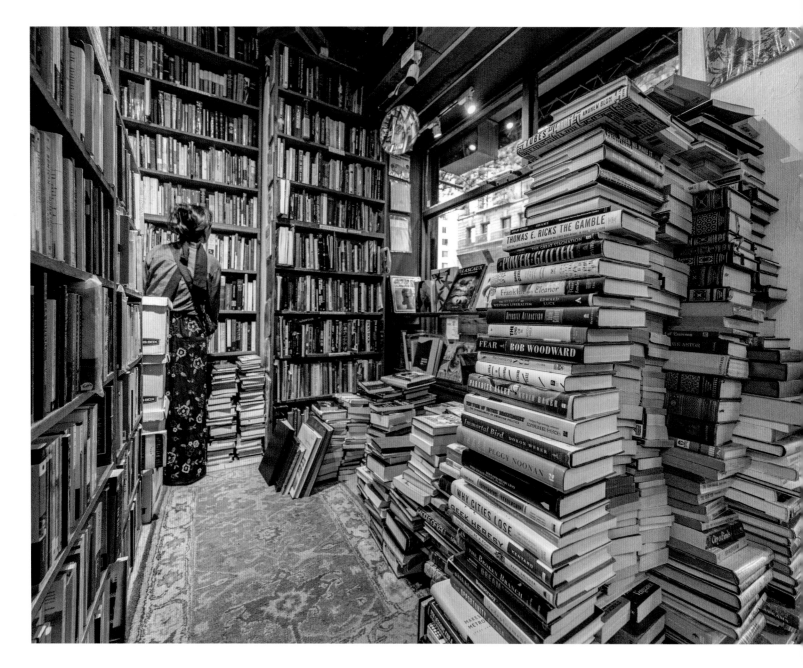

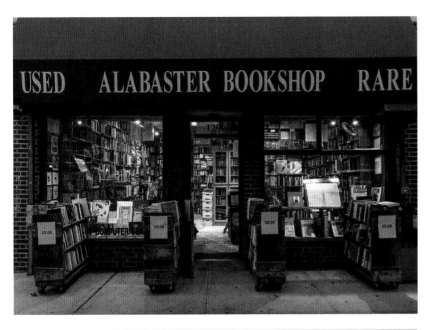

FAR LEFT Well-stocked shelves and piles of books fill the store.

LEFT Alabaster is the only bookshop remaining on Book Row.

BOTTOM LEFT From the first step into the store, visitors can't resist second-hand treasures, stacked high in every corner.

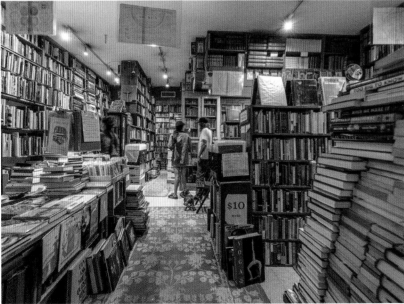

ALABASTER BOOKSHOP
122 4TH AVENUE

Alabaster Bookshop is the last of the second-hand bookstores that once lined 4th Avenue. The historic brownstone near Washington Square Park is chock-full of used books, including rare and well-priced first editions, as well as well-loved popular paperbacks sold at a deep discount. The store also buys rare books, and the owner is known to have hand selected every item on the jam-packed shelves.

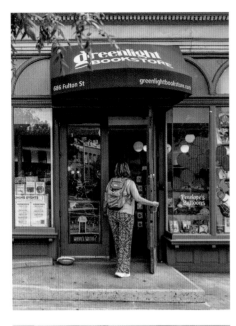

LEFT The Brooklyn store is a busy hub of the community.

BOTTOM LEFT The store hosts regular events for kids.

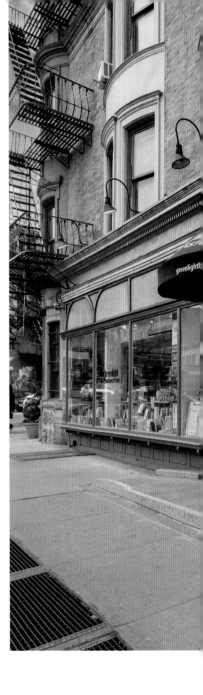

GREENLIGHT BOOKSTORE

686 FULTON STREET (BROOKLYN)

Greenlight Bookstore opened its doors in Brooklyn in 2008, and quickly became the literary centre of a neighbourhood rich with authors and readers alike. It offers events and readings with writers from Brooklyn, and partners with local schools and community institutions, such as the Brooklyn Academy of Music. There are readings, book groups, and kids' events on most days, and a First Editions Club, where readers get a new and signed first edition of a selected book each month. In addition, Greenlight actively supports independent publishers and small local presses, giving up-and-coming voices a chance to connect and share new work.

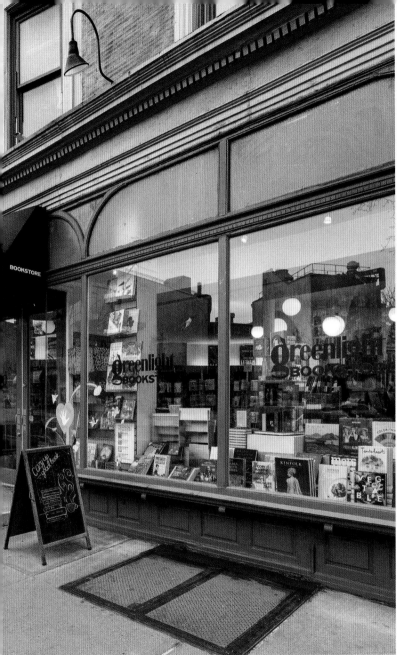

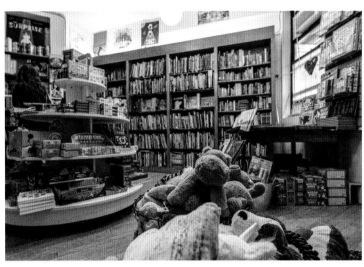

LEFT Greenlight Bookstore quickly became a literary landmark in Brooklyn.

TOP The space welcomes children with a range of toys and books.

ABOVE The bookstore's bright interior.

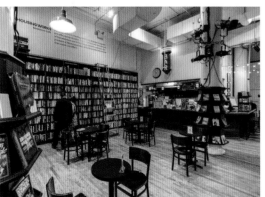

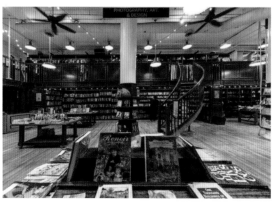

ABOVE The Housing Works Bookstore is a social enterprise located in SoHo.

LEFT A place to buy books, drink coffee, hang out and come together.

FAR LEFT The cosy café is surrounded by books.

HOUSING WORKS
BOOKSTORE

126 CROSBY STREET

Located on Crosby Street in SoHo, the Housing Works Bookstore is not simply a place to donate and buy used books, although you can do both there. Established in 1990, Housing Works is a non-profit organization with a mission to provide healthcare, supportive services, and advocacy for families facing homelessness and HIV/AIDS. The store raises funds for, and hosts events that support, the Housing Works' mission of social justice. You can catch a movie or a performance or a reading, have a coffee or a cocktail, and peek through books, records, magazines, and more.

In New York you are your own person. You may reach out and embrace all of Manhattan in sweet aloneness, or you can go to hell if you want to.

HARPER LEE

Go Set a Watchman

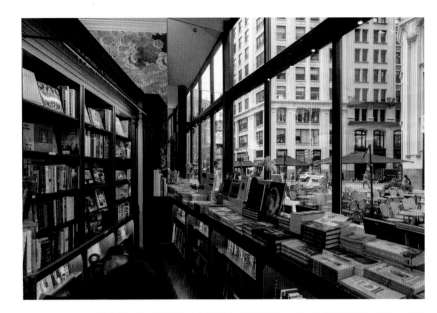

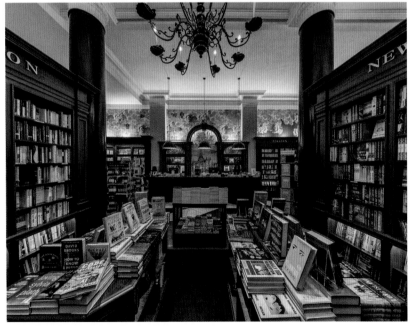

LEFT Rizzoli Bookstore continues to be a literary landmark in New York.

BOTTOM LEFT The historic charm of the building has been celebrated.

RIGHT Rizzoli Bookstore's grand home in the NoMad neighbourhood.

RIZZOLI BOOKSTORE

1133 BROADWAY

Rizzoli first opened in New York in 1964, and moved to its current building in 1985. Located in Chelsea, its spectacular space gives a sense of the kinds of books found inside. Art, architecture, design, photography, and fashion books – often extra-large in size – line the shelves, while illustrations from said books adorn the walls. Rizzoli offers curated subscription boxes for new fiction, non-fiction, art and architecture as well as books from the publisher of the same name. Special events including art shows, concerts and guest lectures fill the calendar and the space with real life art year round.

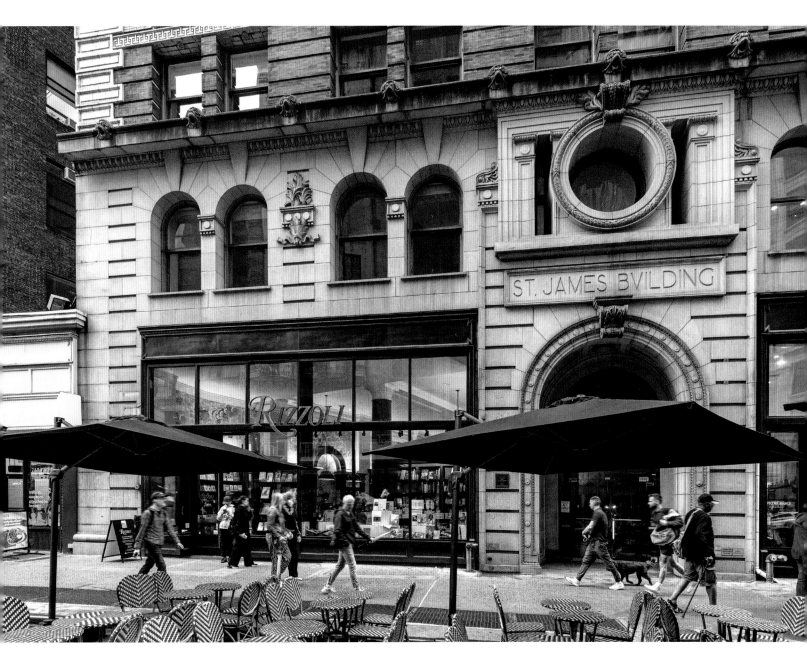

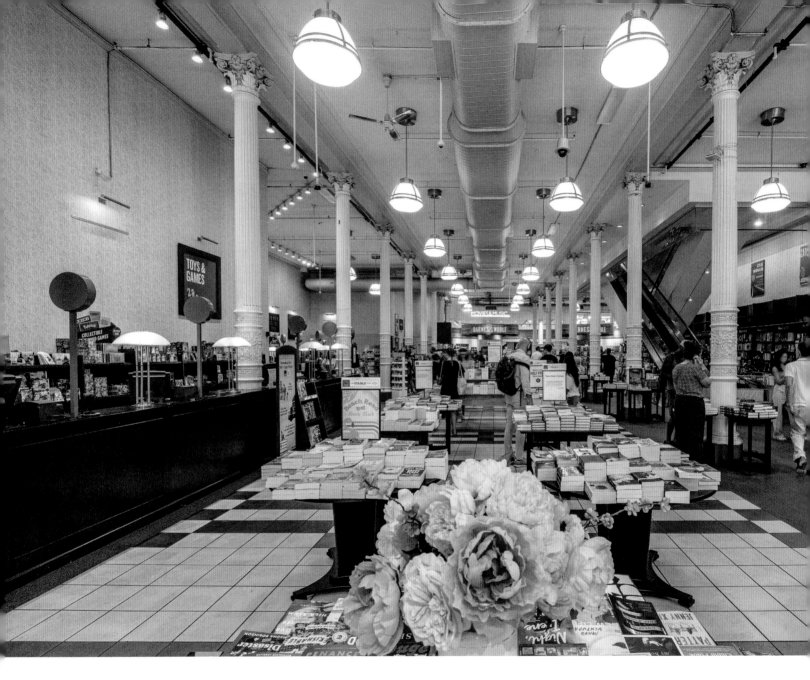

LEFT Barnes & Noble is known for its large stores with cafés inside.

RIGHT The Union Square flagship store is one of the city's largest bookstores.

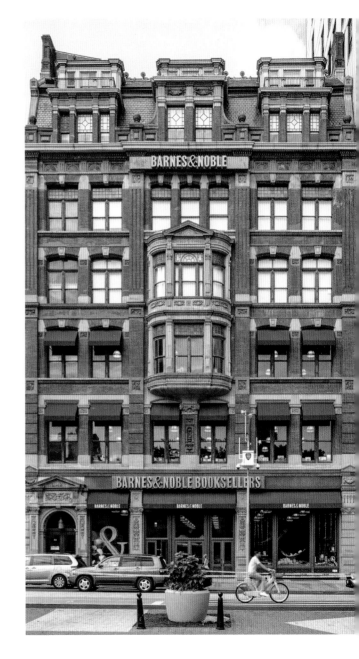

BARNES & NOBLE
(UNION SQUARE FLAGSHIP STORE)
33 EAST 17TH STREET

The Union Square flagship Barnes & Noble store clocks in at 4,650 square metres (50,000 square feet) spread over four storeys full of books, movies merchandize, and more. It's an excellent stop when visiting the city and looking for a place to sit, relax, eat, hop on the free WiFi, and meet new-to-you authors at book talks, clubs, and signings. Stay for an hour or a whole day, and get lost in the magic of the books paired with a great view of Union Square Park, which is right across the street.

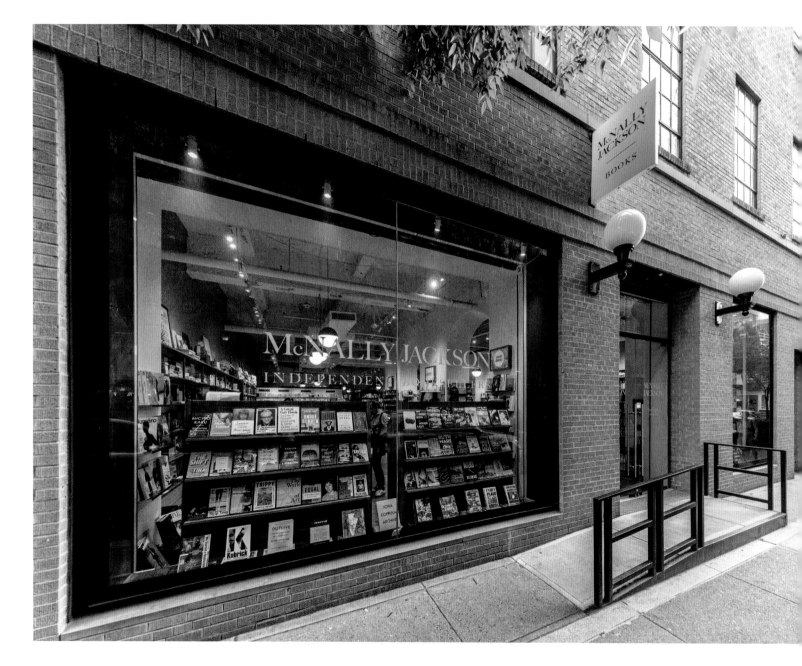

FAR LEFT The inviting window display welcomes book lovers.

LEFT Art and photography are among the many sections on offer.

BOTTOM LEFT The SoHo flagship store is crammed from floor to ceiling.

MCNALLY JACKSON (SOHO FLAGSHIP STORE)

134 PRINCE STREET

Since 2004, McNally Jackson has provided readers with a calming, cosy, and chock-filled respite in the heart of SoHo. Owner Sarah McNally created a store with reading nooks, a café, and an invitation to linger, especially over books by local authors and emerging voices. Each of McNally Jackson's five locations scattered around Manhattan and Brooklyn share the same welcoming vibes, and have special events for readers almost every day of the week. In addition to great books, McNally Jackson is known for a broad collection of literary-themed items like totes, art prints, and unique knick-knacks, making it extra challenging to walk away empty handed.

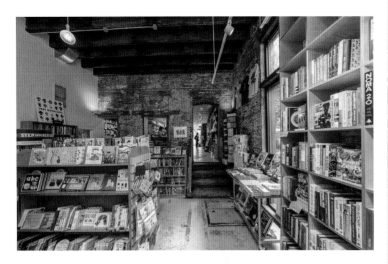

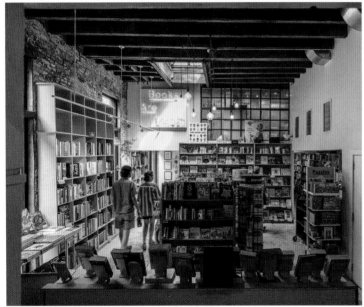

TOP Colourful displays of books and merchandise.

ABOVE The inclusive and vibrant space hosts many events.

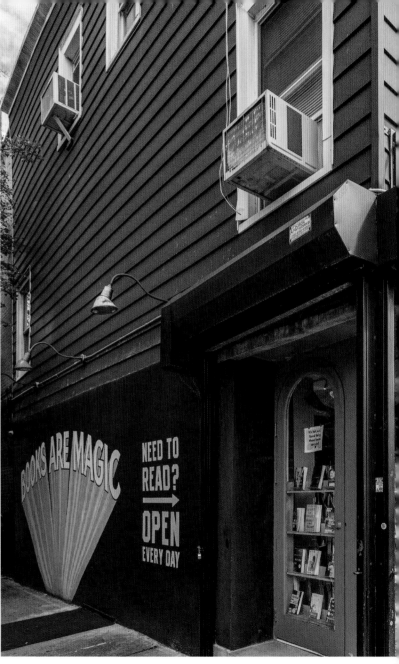

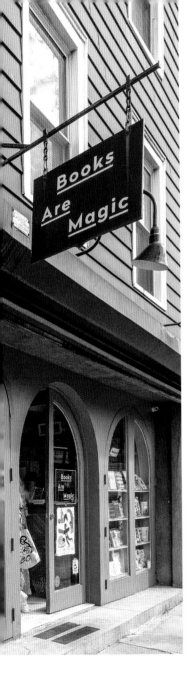

LEFT The Smith Street store in Cobble Hill. Employees are encouraged to share their own candid reviews on the display shelves.

BOOKS ARE MAGIC

225 SMITH STREET (BROOKLYN)

Author Emma Straub and her husband Michael Fusco-Straub opened their whimsical bookstore in Cobble Hill in Brooklyn in 2017, and opened a Brooklyn Heights store in 2022. The store is known for lively panel discussions that bring together a mix of authors, especially those who live and write in the surrounding neighbourhoods, for championing diverse and marginalized voices, and for being a fun and welcoming place for children to discover the joys of reading. They also have a great selection of literary merch for all ages, complete with tongue-in-cheek inside jokes about books and Brooklyn.

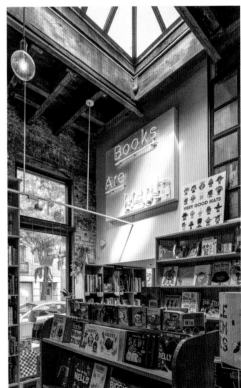

RIGHT The pink storefront in Park Slope.

BOTTOM RIGHT Run by two sisters, this pretty-in-pink store specializes in the romance genre.

FAR RIGHT The decor includes myriad books stuck to the walls.

THE RIPPED BODICE

218 5TH AVENUE (BROOKLYN)

Sisters Leah Koch and Bea Hodges-Koch opened The Ripped Bodice in Culver City, California, in 2016 with $90,000 raised from a Kickstarter campaign. The independent romance-only bookstore proudly prioritizes swoon-worthy novels that often get treated like second-class prizes in more traditional bookstores. The Brooklyn site opened in the Park Slope neighbourhood in 2023, branching out to bring their topic-forward categorization to the East Coast.

At The Ripped Bodice, books are featured by sub-genre instead of the authors' last name, allowing voracious romance readers to get lost in the historical fiction or fantasy they prefer. The sisters promote books by authors of colour in their stores, and advocate for broader representation in romance publishing, especially for LGBTQ+ titles. The Ripped Bodice holds its own yearly awards for romance, hosts writing nights for the next generation of romance writers, and offers panels with writers and experts in romance and pleasure. While it might be a new addition to the New York bookstore scene, The Ripped Bodice is just getting started.

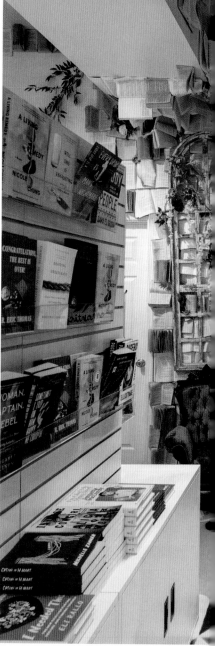

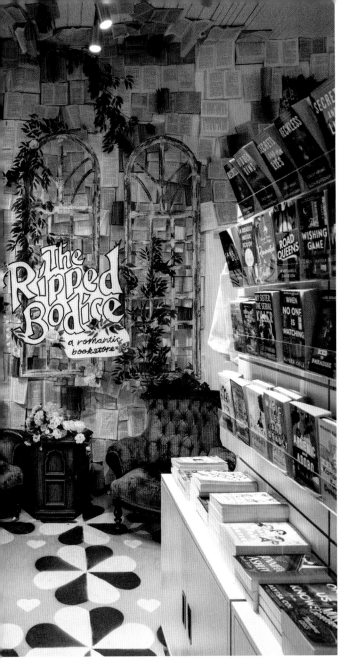

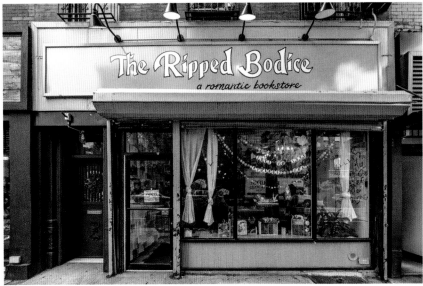

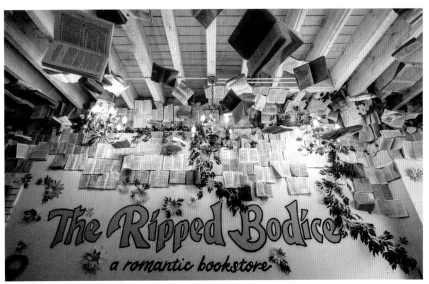

TOP The Brooklyn store, which opened in 2023, was their second site.

ABOVE Books hang from the ceiling and adorn the walls.

I started reading. I read everything I could
get my hands on...By the time I was thirteen
I had read myself out of Harlem. I had read
every book in two libraries and had a card
for the Forty-Second Street branch.

JAMES A. BALDWIN

New York is an ugly city, a dirty city. Its climate
is a scandal, its politics are used to frighten
children, its traffic is madness, its competition is
murderous. But there is one thing about it: once
you have lived in New York and it has become
your home, no place else is good enough.

JOHN STEINBECK

America and Americans

LIBRA

RIES

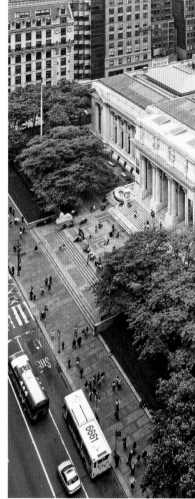

NEW YORK PUBLIC LIBRARY

476 5TH AVENUE

The main building of the New York Public Library is a Beaux Arts masterpiece built by architecture firm Carrère and Hastings. It features a facade of classical details, including columns and lion sculptures, which reflect the architectural opulence of New York City in 1914 when it was built. The inside is equally spectacular, with incredible frescoes on high ceilings, marble staircases, hand-carved woodwork, and stained-glass windows. The library houses many important and historic books, manuscripts, and other literary materials, including a rare copy of the *Declaration of Independence*, a copy of the *Gutenberg Bible*, and John James Audubon's *Birds of America*, complete with hand-coloured plates. It also has medieval manuscripts and religious texts, mixed in with contemporary writings, first editions, and archival materials from writers such as F. Scott Fitzgerald, Edith Wharton, and J.D. Salinger, all of whom are said to have used the quiet peace here to work on some of their most beloved books.

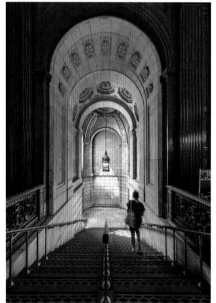

ABOVE AND TOP Beautiful staircases in the historic library.

ABOVE The main entrance on 5th Avenue.

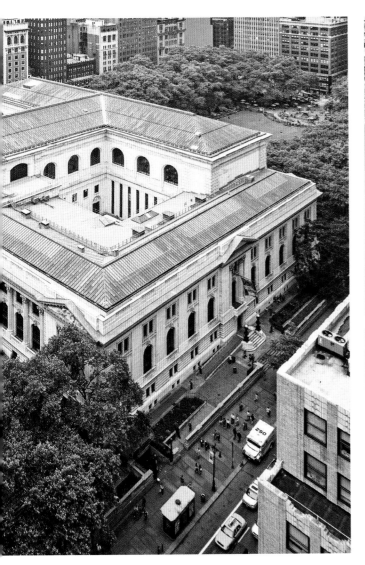

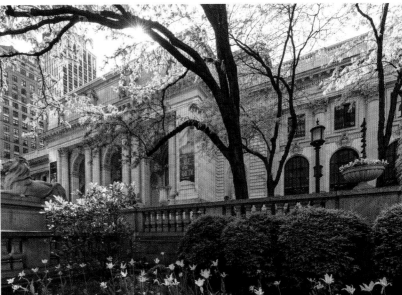

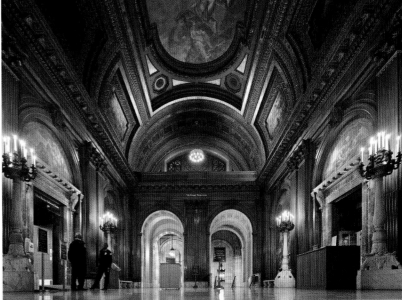

TOP The marble facade of the iconic library.

RIGHT Hand-carved woodwork adds to the splendour of the building.

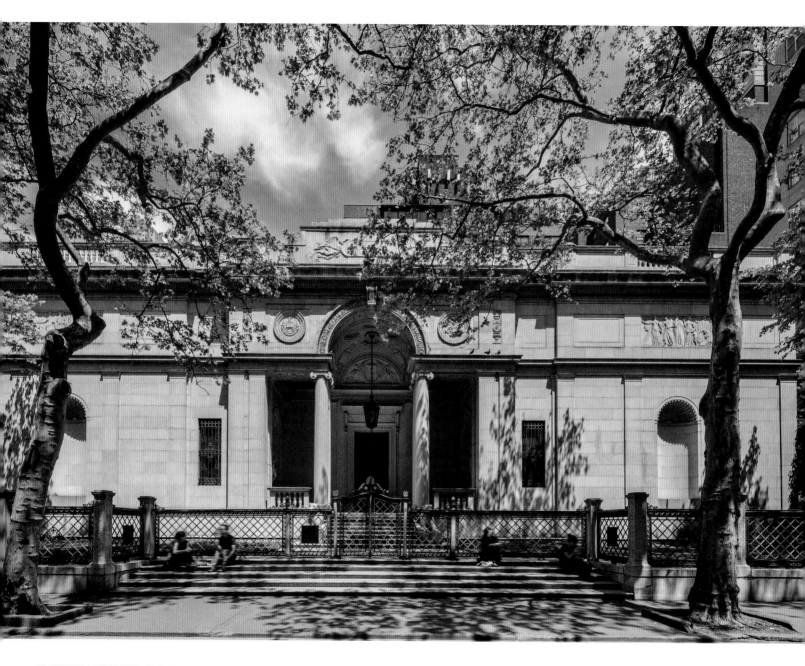

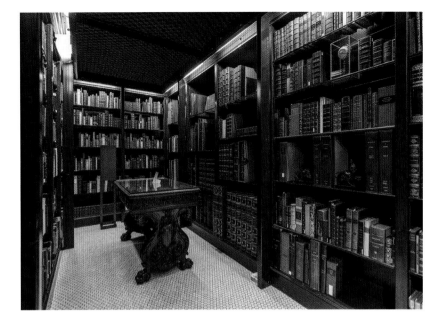

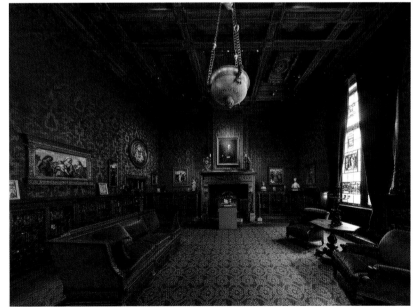

LEFT The library is a New York City designated landmark.

RIGHT Morgan's secure vault, which housed the most valuable works.

BOTTOM RIGHT Morgan's personal study.

THE MORGAN LIBRARY & MUSEUM
225 MADISON AVENUE

The Morgan Library & Museum was originally the private library of financier John Pierpont Morgan. Built in 1906, the facade has Corinthian columns and an impressive rotunda. The inside is equally impressive with vaulted ceilings and elegant furnishings from the Gilded Age of New York. Tucked between rare books, ancient artefacts, and art exhibits is the personal study of Morgan, unchanged since his lifetime. The complex has expanded to include the Gilder Lehrman Hall performance space, the Morgan Stanley Galleries, a café, and garden. Tours and special events, including lectures, musical performances, and art exhibits, are scheduled with frequency, and advance tickets are recommended, although not required.

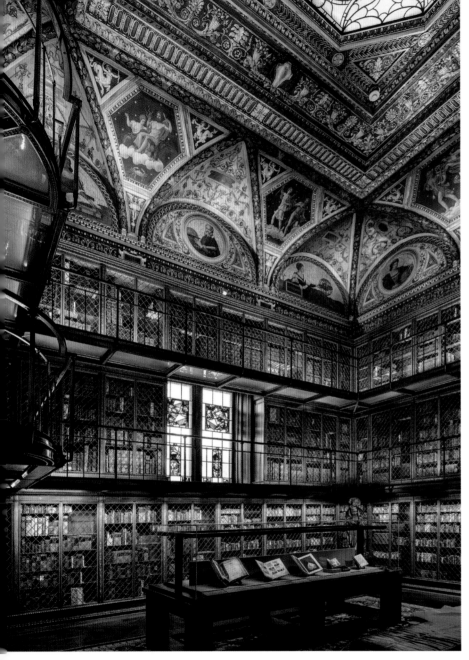

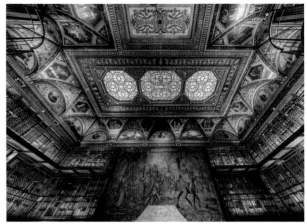

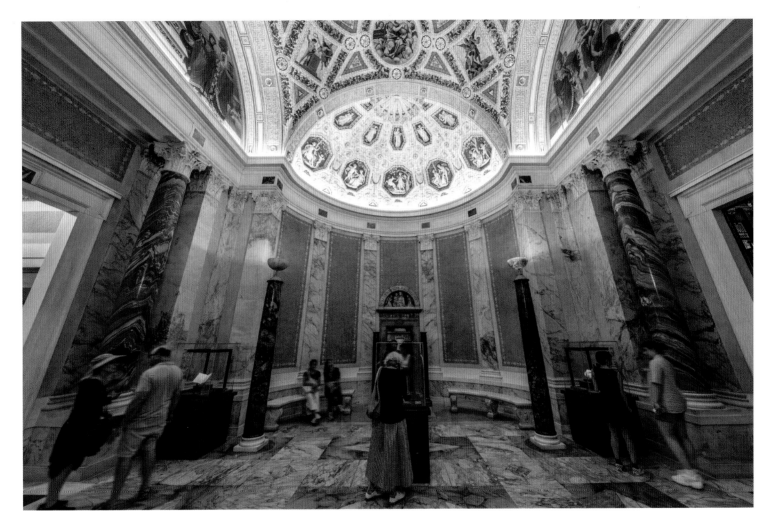

FAR LEFT Three tiers of bookshelves in the Morgan Library's East Room.

TOP LEFT The complex ceiling of the grand East Room.

LEFT Intricate stained glass window detail.

ABOVE The opulent rotunda with its ornate detailing on the floors, walls and columns.

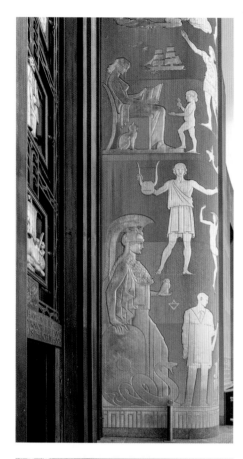

LEFT Art Deco detailing on either side of the main doors.

BOTTOM LEFT Fifteen bronze sculptures adorn the doors.

RIGHT The book-shaped library from above.

BROOKLYN PUBLIC LIBRARY

10 GRAND ARMY PLAZA

The Brooklyn Public Library, also known as Central Library, is said to look like a book if viewed from above. The Art Deco style features sleek lines, geometric patterns, and bright decorative metalwork. Inside, the design continues with bold colours, polished surfaces, curved walls, and large windows, which let in natural light to show off the books, stacks, and reading nooks. Architects Alfred Morton Githens and Francis Keally designed the building during the Great Depression to boost the economy and provide services for the surrounding neighbourhoods. Since opening in 1941, the library has stood as a symbol of progress and learning, serving classic literature, contemporary bestsellers, rare manuscripts, and books by notable Brooklyn authors. It hosts classes, author talks, and special events for the Brooklyn Book Festival, which is held in September each year.

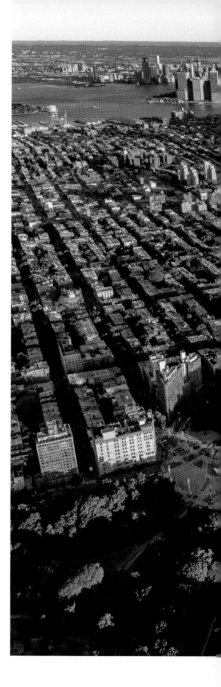

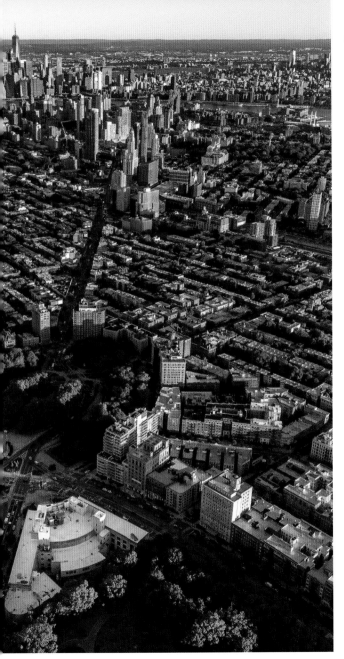

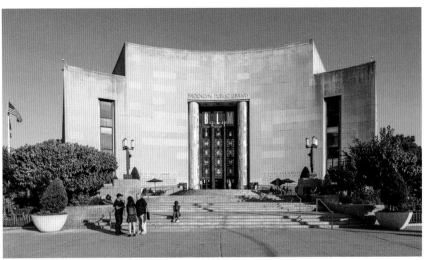

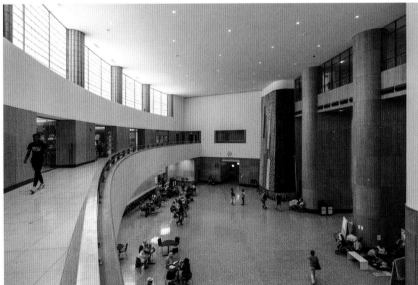

TOP The concave entrance resembles the spine of the book.

ABOVE The bright, modern interior.

NEW YORK SOCIETY LIBRARY
53 EAST 79TH STREET

The New York Society Library was the very first in the city, dating all the way back to 1754 when six Good Samaritans decided the city's citizens would benefit from a place where they could borrow books. It originally opened in City Hall on Wall Street at Broad Street, with a Charter from George III in 1772. It was looted by British soldiers in the Revolutionary War, and reopened afterwards by the confirmation of the New York State Government. After New York became the new national capital, the library became a part of Federal Hall in 1789 and became the first Library of Congress. There are two records of George Washington borrowing books that were never returned, until one was brought back in 2010. Between 1789 and 1805, forty-two members of Congress borrowed books, and the records can still be searched today. Since its opening, the library has moved location four times: to Nassau Street where Washington Irving and James Fenimore Cooper visited; Leonard Street where Henry David Thoreau and John Audubon roamed the stacks; to University Place where Herman Melville and Willa Cather researched, wrote and borrowed books; and finally to its current location in 1937. Since then, Truman Capote, Wendy Wasserstein, and David Mamet, among many others, have spent time researching their books and writing in the site's quiet elegance. The library offers yearly memberships, and also day passes for those who want to come and take a look.

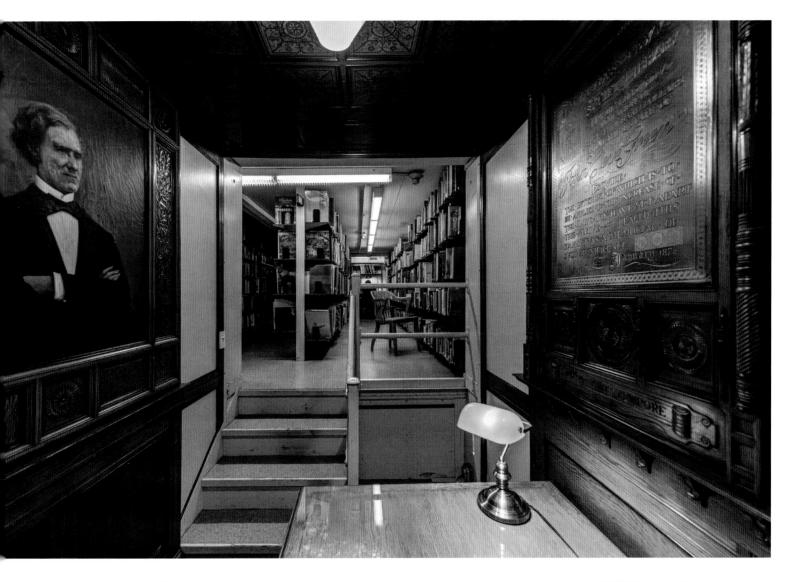

TOP LEFT Shelves are packed full of books.

BOTTOM LEFT Card catalogue drawers.

ABOVE The Green Alcove is a popular space for quiet reading and study.

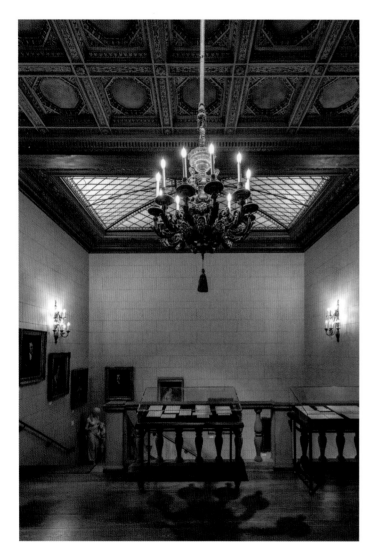

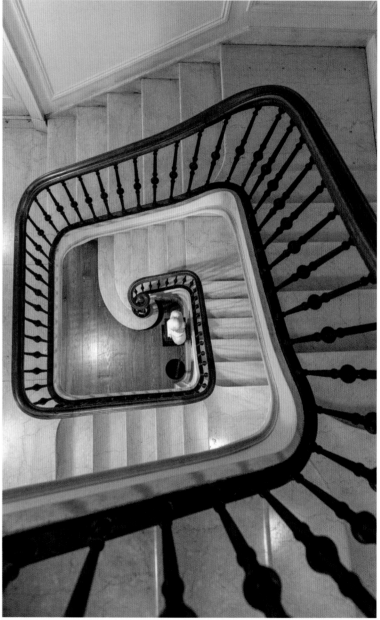

ABOVE The building was originally a townhouse and was converted into a library in 1937.

RIGHT Featuring a leaded skylight and an impressive spiral, this staircase is considered one of the most dramatic in New York City.

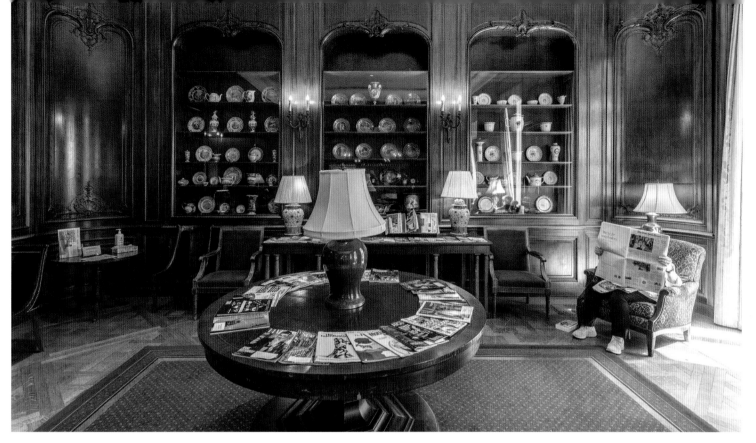

ABOVE The members' room is available for literary events.

LEFT Art from all periods of history is displayed around the library.

FAR LEFT The inviting space of the children's library.

> Sometimes, from beyond the skyscrapers, the cry of a tugboat finds you in your insomnia, and you remember that this desert of iron and cement is an island.

ALBERT CAMUS

NEW YORK PUBLIC LIBRARY (JEFFERSON MARKET LIBRARY)

425 6TH AVENUE

This Greenwich Village library, voted one of the top-ten most beautiful buildings of the 1880s, began its days in 1877 as a courthouse and police station. Today's adult reading room was once a civil court, the children's room was a police court, and the reference room in the basement was a place where prisoners waited before going to trial or jail. *Red Badge of Courage* author Stephen Crane once testified here in defence of a prostitute, and Mae West was arrested and tried for obscenity for writing and performing her show *Sex*. After that, it became a symbol for artistic freedom and creative expression. The courthouse closed in 1945, and the building became a training facility for the Police Academy. By 1959, it had been abandoned and taken over by pigeons and rats, and NYC decided to knock it down. A group of concerned West Village citizens, including architectural historians Margot Gayle, Philip Wittenberg, Lewis Mumford, and poet E. E. Cummings, who lived across the street, convinced the city to turn the building into the library that still stands today. The Jefferson Market Library holds collections of materials specializing in Greenwich Village History, LGBTQ+ rights, and urban studies, and is rumoured to be haunted by the ghost of a former librarian named Annabelle, who roams the stacks, rearranges books, and whispers secrets at night.

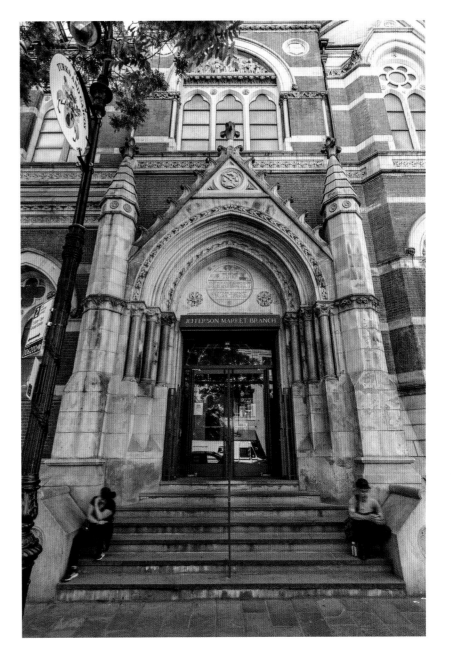

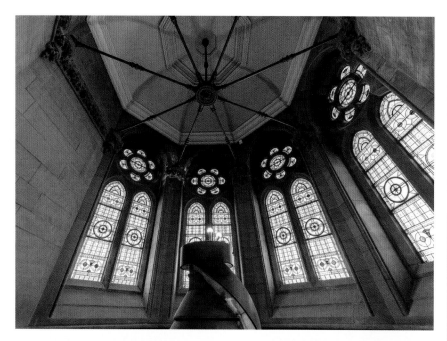

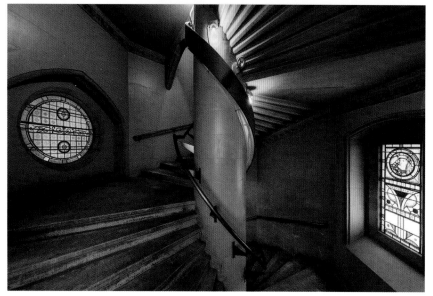

ABOVE The old courthouse was transformed into a literary landmark.

TOP LEFT AND LEFT The spiral staircase inside the tower leads up to stunning stained glass windows.

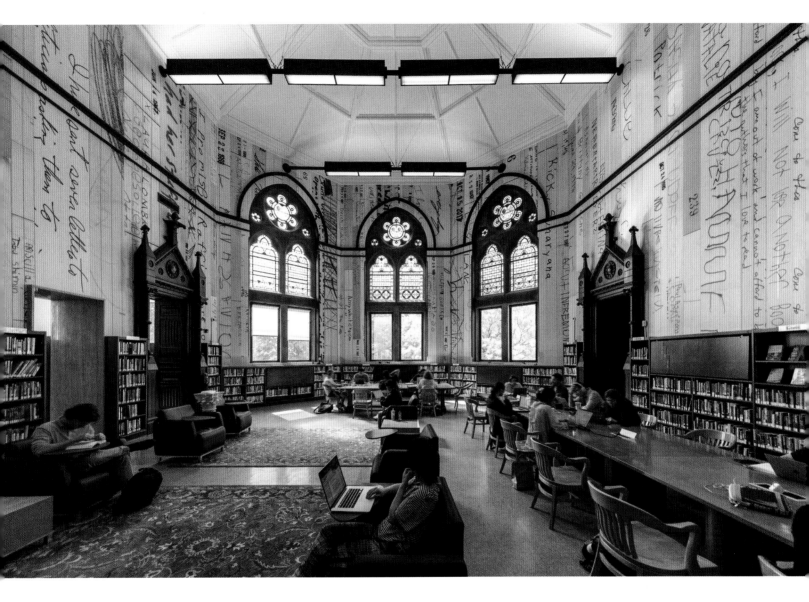

ABOVE The adult reading room
was once the civil court.

And New York is the most beautiful city in the world? It is not far from it. No urban night is like the night there.... Squares after squares of flame, set up, and cut into the aether. Here is our poetry, for we have pulled down the stars to our will.

EZRA POUND

Coming to New York from the muted mistiness of London, as I regularly do, is like travelling from a monochrome antique shop to a technicolour bazaar.

KENNETH TYNAN

HOTELS &

RESTA

URANTS

RIGHT The luxurious hotel has been a landmark in New York for over a century.

BOTTOM RIGHT The iconic five-star hotel is located in Midtown Manhattan.

THE PLAZA HOTEL

785 5TH AVENUE

Since opening in 1907, The Plaza has stood as a symbol for the opulence and luxury of turn-of-the-century New York. Built by banker Bernhard Beinecke, hotelier Fred Sterry, and architect Henry Janeway Hardenbergh, and designed in the architectural style reminiscent of a French Renaissance chateau, The Plaza has eighteen floors of bars, restaurants, condos, and hotel rooms. F. Scott Fitzgerald was a frequent guest in the 1920s; the luxury and extravagance he wrote about when his *Great Gatsby* characters come from East Egg to Manhattan is said to be inspired by the hotel. Truman Capote was another frequent guest who could be found entertaining friends and fellow writers in the Oak Room Bar, or hosting his Black and White Ball in the ballroom. Ernest Hemingway supposedly wrote parts of *The Sun Also Rises* while at The Plaza, and Agatha Christie stayed and wrote there, too. But only one fictional character has their own room at The Plaza today, and that's beloved children's book *Eloise*. In the books, the heroine Eloise, her nanny, turtle, and dog get up to all kinds of mischief in The Plaza Hotel. Fashion Designer Tommy Hilfiger turned one of the Plaza's turrets into an ode to the fictional character. Visitors can stay in a suite inspired by her, and go for *Eloise* Afternoon Tea in the Palm Court Restaurant too.

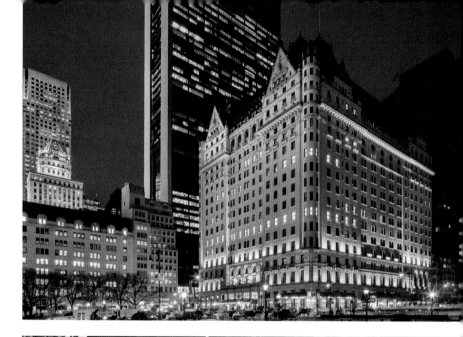

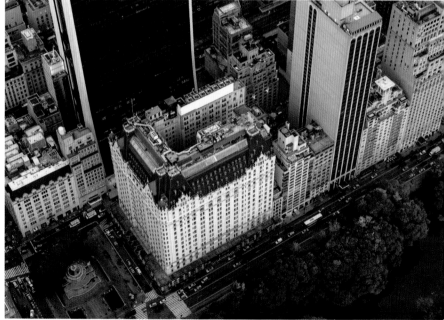

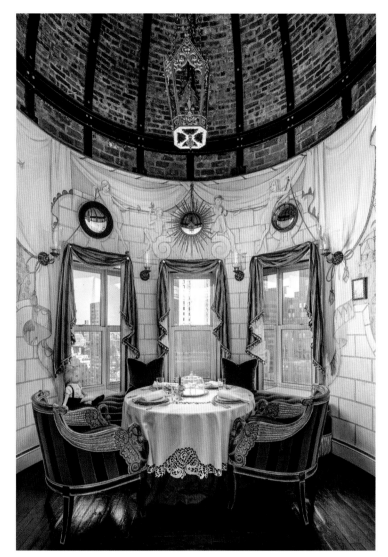

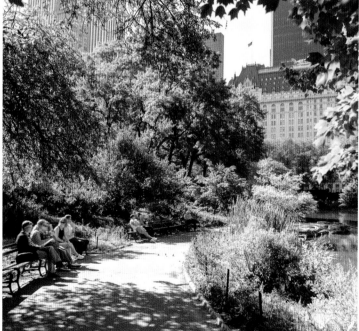

ABOVE The opulent Dome Penthouse is a private residence containing the building's turret which is hand painted and set in homage to the tea party from the children's book *Eloise*.

TOP RIGHT The hotel's grand doors where many famous writers have made their entrance.

RIGHT The hotel as viewed from the tranquillity of Central Park.

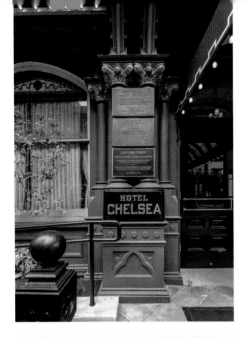

THE HOTEL CHELSEA

222 WEST 23RD STREET

With its Victorian Gothic architecture and Chelsea locale, The Hotel Chelsea is home to creative folks who are drawn to its bohemian style and storied building. Built as a co-op before there were many apartments in the city, it was intended from the start to create a community for artists of all kinds, providing long- and short-term affordable housing in the centre of Manhattan. The Chelsea was quite technologically advanced when it opened, with electricity, steam heating, and hot and cold water. The guest book reads like a who's who of art, music, theatre, and literature. Writers include Dylan Thomas, Jack Kerouac, Vladimir Nabokov, Mark Twain, Gore Vidal, and Tennessee Williams are among the many who lived (and died, in Dylan Thomas' case) here. While living at The Chelsea, Arthur C. Clark wrote *2001: A Space Odyssey*, Thomas Wolfe penned *You Can't Go Home Again*, and William S. Burroughs authored *Naked Lunch*. As for books about the building itself, *Chelsea Girls* by Eileen Myles and *The Chelsea Girls* by Fiona Davis feature the building like a character, and in Patti Smith's memoir *Just Kids*, the hotel shines as a backdrop to Smith's time as a young and struggling artist when she lived here with Robert Mapplethorpe.

On the first floor of The Chelsea is El Quijote, a restaurant named after the title character in Miguel de Cervantes' *Don Quixote*. Murals along the walls feature scenes from the story, and the food and drink menus are full of Spanish influences inspired by the novel. Years of stories on and off the page have taken place in the restaurant and in all the rooms of The Chelsea. With a new renovation completed in 2022, it's poised to keep inspiring creativity and community for years to come.

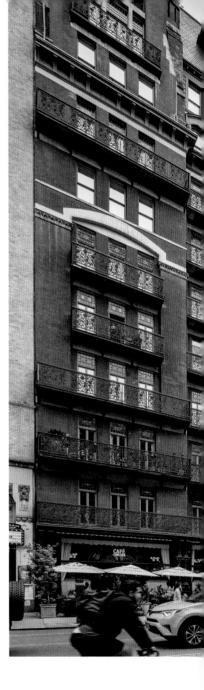

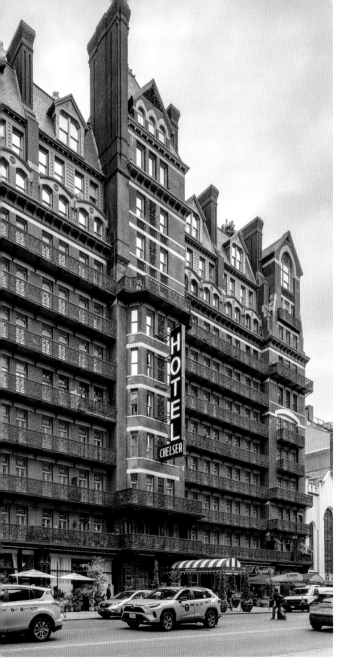

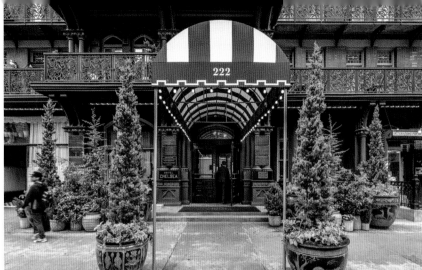

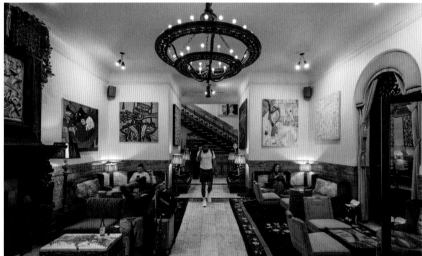

FAR TOP LEFT Plaques dedicated to various luminaries with connections to Hotel Chelsea.

FAR BOTTOM LEFT The lobby of the hotel maintains its elegance after a renovation in 2022.

LEFT The red-brick building with its iconic wrought-iron balconies is a cultural landmark in the city.

TOP The grand entrance on West 23rd Street

ABOVE The luxurious lobby.

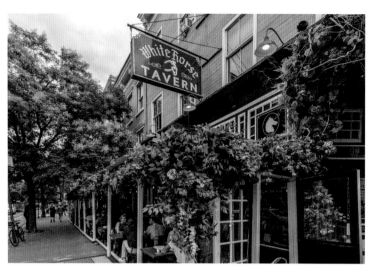

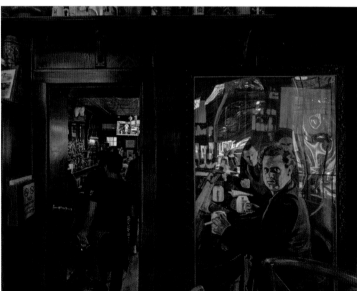

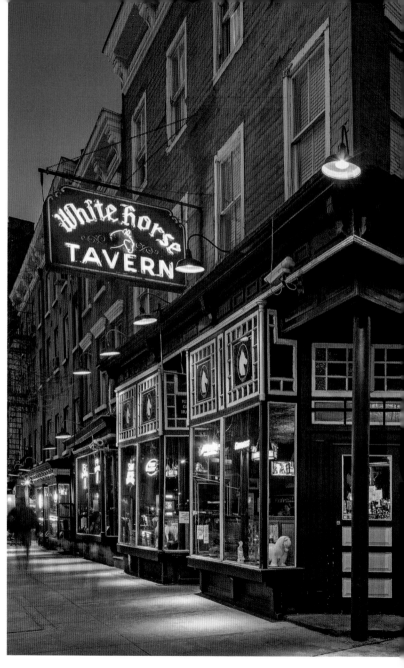

TOP The popular outdoor seating is often packed with people enjoying food and drinks.

ABOVE A life-size portrait of Dylan Thomas hangs in White Horse Tavern.

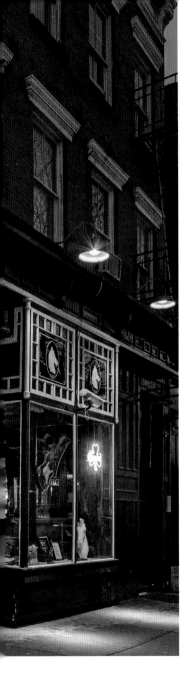

LEFT White Horse Tavern is located on the corner of Hudson and 11th Street.

RIGHT Known for its old-school charm, this is one of the oldest bars in New York City.

BOTTOM RIGHT Famous patrons included Dylan Thomas and Jack Kerouac.

WHITE HORSE TAVERN

567 HUDSON STREET

White Horse Tavern opened as The Great Atlantic in 1880, but quickly changed its name. It was built by Polish immigrant Edward Erickson and originally attracted longshoremen and other working folks who lived in Greenwich Village. In the mid-nineteenth century, it gained popularity with the counter culture writers of the Beat Generation and became a hangout for Allen Ginsberg, Hunter S. Thompson, and Jack Kerouac, who had to be removed on more than one occasion after drinking too much. James Baldwin, Norman Mailer, Edna St. Vincent Millay, and Djuna Barnes also frequented the White Horse. It is best and most sadly known for being the place where Irish poet Dylan Thomas drank copious amounts of whiskey before stumbling back to The Hotel Chelsea (see p62) to die at the far-too-young age of thirty nine. Today, a large picture of Thomas hangs in White Horse, and fans visit to pay homage to his life and work.

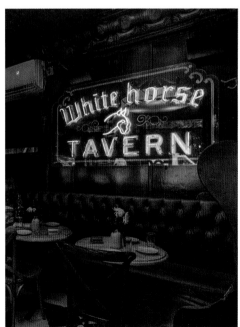

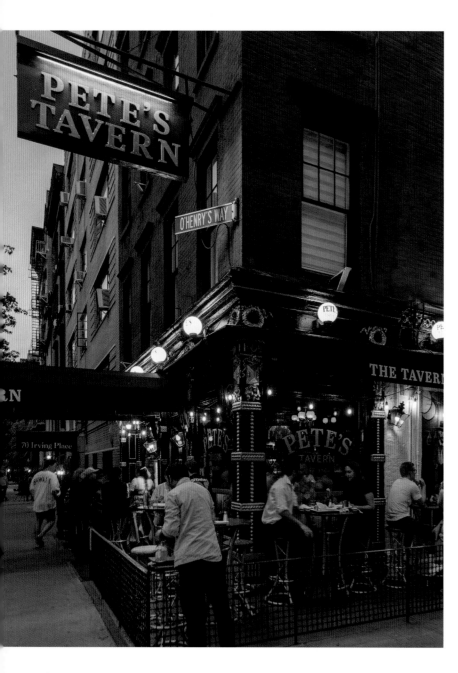

PETE'S TAVERN

129 EAST 18TH STREET

Pete's Tavern, part of the Gramercy Park historic district, has been serving liquor continuously in this location since 1864, even during Prohibition when it was disguised as a flower shop. It has had a number of names and owners over the years, including Healy's, its title in 1904 when O. Henry penned the short story *The Gift of the Magi* in the second booth from the front, where visitors can still sit today. The thirty-foot rosewood bar is original, and the same spot that served William Faulkner, Arthur Conan Doyle, E. E. Cummings, and John Dos Passos. Owner Peter D'Belles changed the name when he bought the place in 1926, and current proprietor Gary Egan has chosen to keep it along with the history, the design, and the stories it represents.

THE ODEON

145 WEST BROADWAY

The Odeon in Tribeca opened in 1980, after restaurateurs Lynn Wagenknecht, Keith McNally, and Brian McNally visited Paris together and decided that New York needed a French-inspired brasserie. It quickly made a name for itself when it was included in the opening credits of *Saturday Night Live* for the 1981–2 season. It was known for culinary delights in addition to pop culture cool, serving fresh food with local ingredients and creative cocktails. Odeon bartender Toby Ceccini is credited with creating the iconic version of the Cosmopolitan, which became *the* drink of the '90s, famously enjoyed by Carrie Bradshaw and her friends in *Sex and the City*. Resembling a Vodka Gimlet, his version is said to be inspired by a similar recipe from San Francisco.

The vibrant bar scene attracted all kinds of creatives living in lower Manhattan in the 1980s, including John Belushi, Andy Warhol, and John-Michel Basquiat, and writers including Bret Easton Ellis, Donna Tartt, Tama Janowitz, and Jonathan Lethem, who spent time there together along with Jay McInerney. The Odeon featured on the cover and in the pages of McInerney's *Bright Lights, Big City*, which was both a commercial and critical hit. The main character is an aspiring writer who spends time lost in the decadence and drugs of the 1980s, and The Odeon is a frequent part of the fictional fabric, which very much captured the zeitgeist of NYC at that time.

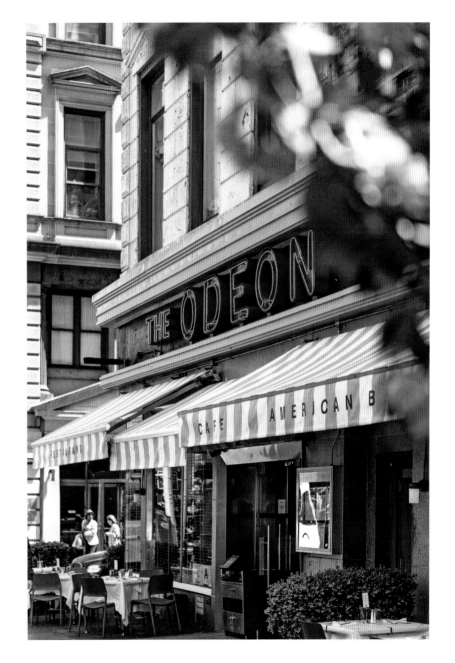

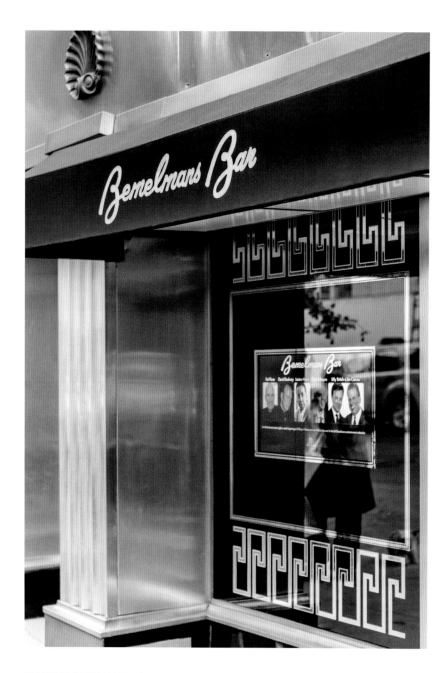

BEMELMANS BAR

35 EAST 76TH STREET

Bemelmans Bar is a cocktail lounge and piano bar located on the Upper East Side in The Carlyle Hotel, which opened in the late 1940s. Ludwig Bemelmans, the lauded author and illustrator of the *Madeleine* books, was a frequent guest. Legend has it that he was eating in the bar, and offered friend and general manager Robert Huyot a hand-painted redesign of the bar in exchange for a place for his family to live. While they stayed in The Carlyle, Bemelmans kept his promise, putting his beloved characters into scenes in his iconic style all over New York City including Central Park, Bethesda Terrace, Brooklyn Bridge, and Times Square. He even drew himself! While the style is in alignment with the children's books, it pairs with the sophisticated decor and inventive cocktail menu that has been enjoyed by many other authors over the years, including Truman Capote, Gore Vidal, Dorothy Parker, and Tennessee Williams.

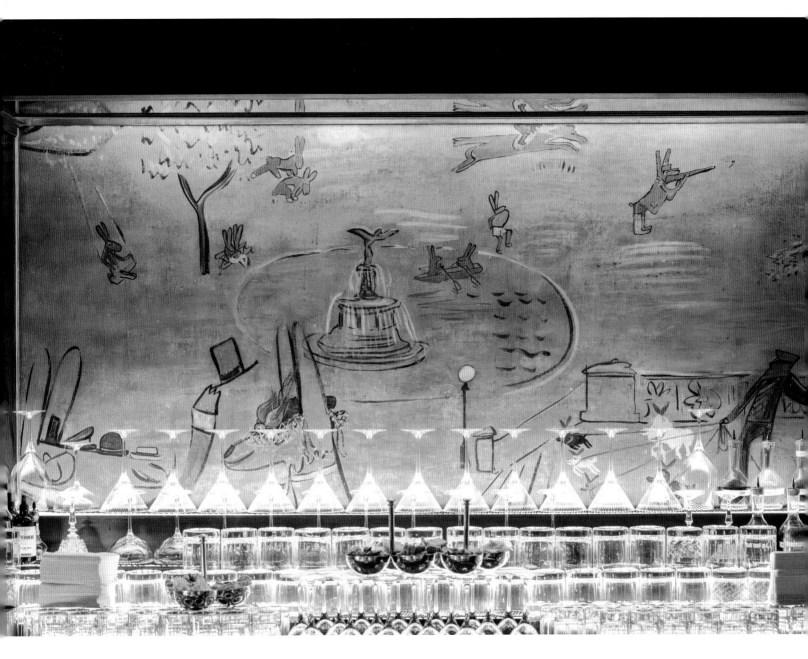

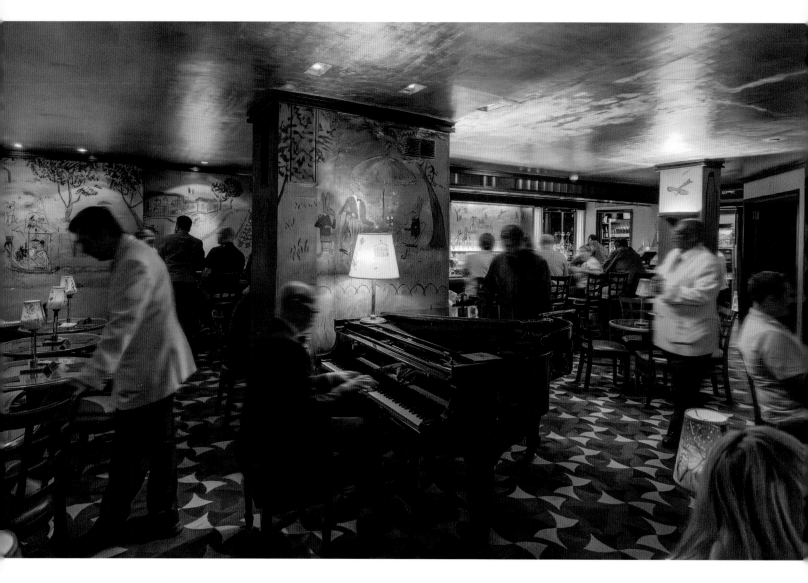

ABOVE The bar is famous for its atmosphere and acoustics.

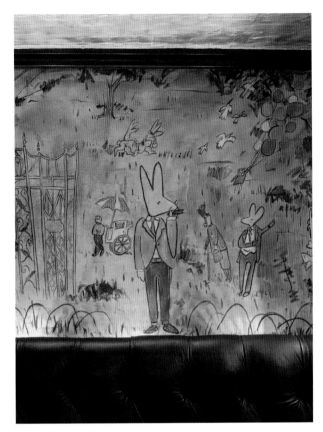

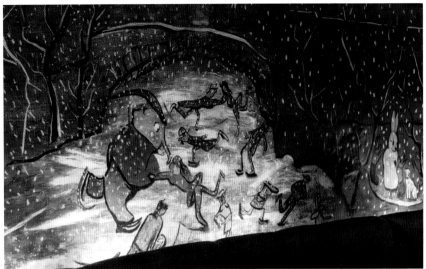

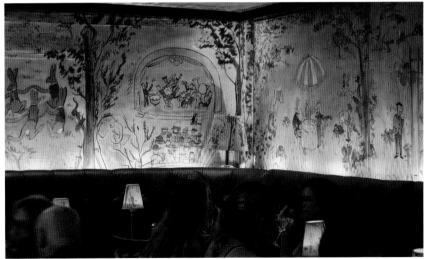

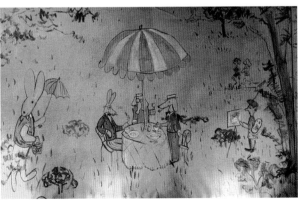

TOP LEFT, LEFT AND TOP RIGHT Murals by Ludwig Bemelmans cover the walls.

ABOVE Small lamps add an amber glow to the cocktail bar.

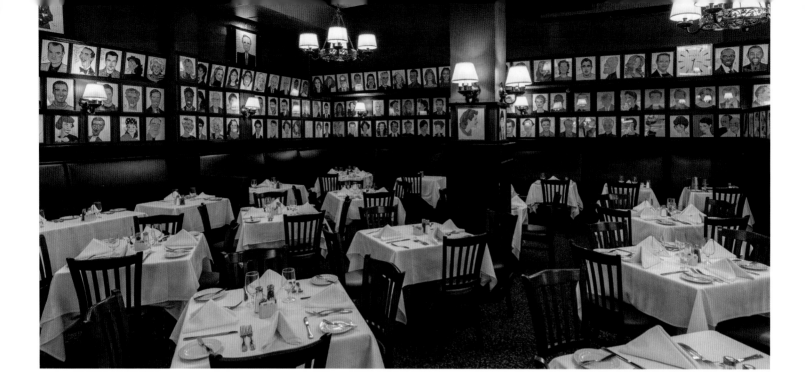

SARDI'S

234 WEST 44TH STREET

Sardi's restaurant, located in the Broadway Theatre District, has served so many actors, directors, and writers that its nickname is Theatre Row's Playwright. It's famous for opening night parties, late hours, and post-show meals. The husband and wife team of Vincent Sardi Sr and Eugenia 'Jenny' Pallera opened their first restaurant in a nearby building that was targeted for demolition to build the St. James Theatre. The Shubert Brothers, who built the St. James, along with much of Broadway, offered the couple a chance to relocate down the block.

They reopened in March of 1927 as Sardi's, but business was slow after the move. A group of writers and drama critics known as the Cheese Club (including Alexander Woollcott, Harpo Marx, Dorothy Parker, and Heywood Broun) met frequently here for lunch. It was a member of that group who brought artist Alex Gard to dine with them. While there, Gard did some caricatures of the Cheese Club, and Sardi Sr. hung the drawings above their table. Recalling a jazz club in Paris with similar drawings all over the walls, Sardi Sr. hired Alex Gard to do more drawings in exchange for one meal a day. For more than twenty years, Gard did live drawings of the most famous and fabulous stars of the Broadway nebula, more than seven hundred in all. Many writers can be spotted among the pictures lining the walls, including Neil Simon, Dorothy Parker, Tennessee Williams, and Lillian Hellman. They sit beside actors, musicians, politicians, and many others who enjoyed a meal, a party, or a drink at this legendary Broadway hotspot.

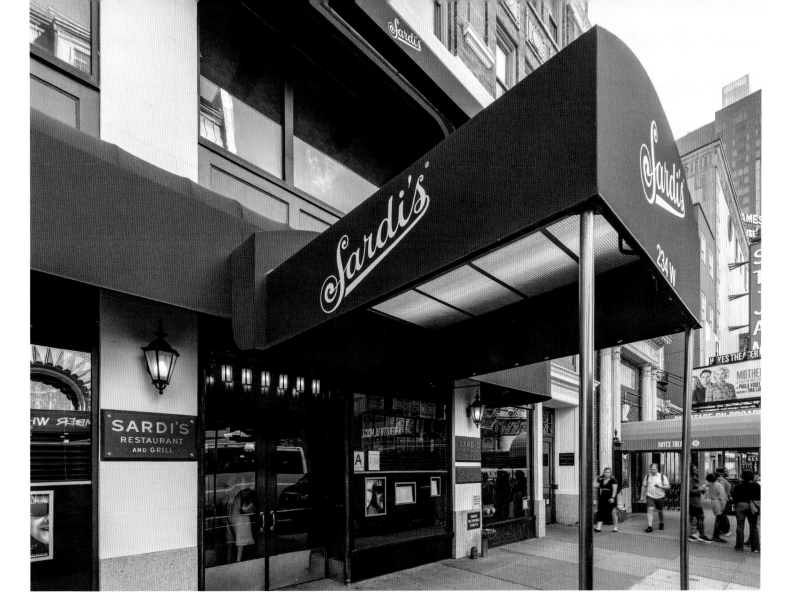

LEFT Alex Gard's caricatures surround the restaurant.

ABOVE A Broadway landmark for a century.

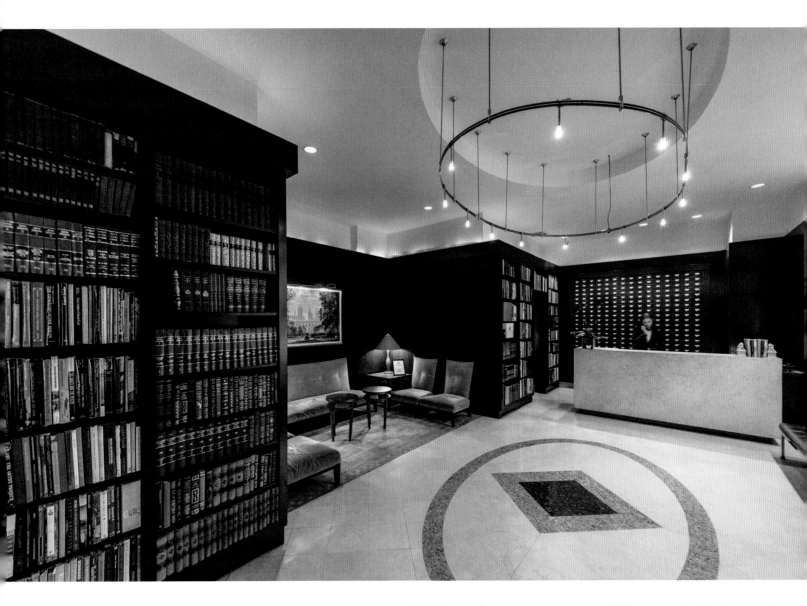

ABOVE The hotel's main entrance is on 41st Street, known as 'Library Way'.

RIGHT Every room is individually adorned with books based on a distinctive topic.

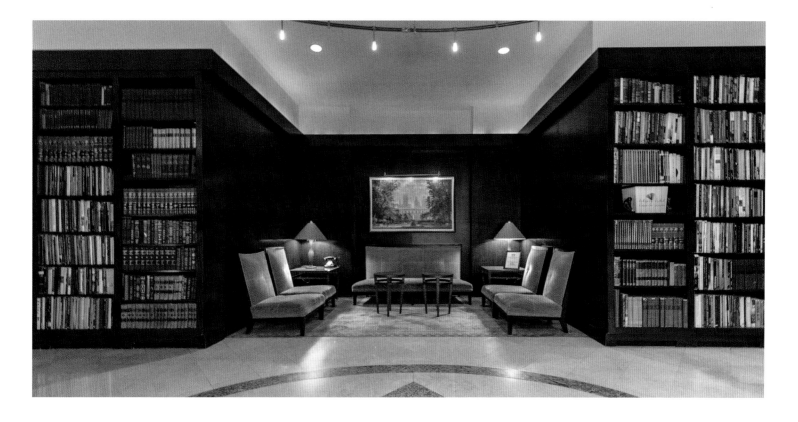

THE LIBRARY HOTEL

299 MADISON AVENUE

Built for anyone who ever dreamed of a library sleepover, this Madison Avenue boutique hotel is themed like a library. The hotel includes a dedicated reading room and a rooftop writer's den and poetry lounge with literary-themed cocktails. Every floor is categorized and themed according to the most popular classifications in the Dewey Decimal System, and each room has at least one hundred books dedicated to that particular subject area. The Dewey Decimal System comprises ten categories: social sciences; literature and rhetoric; language; history, biography, and geography; natural sciences and mathematics; general works; technology; philosophy and psychology; the arts; and religion. Guests can request rooms with themes important to them. In 2003, OCLC (Online Computer Library Center), the owners of the copyright for the Dewey Decimal System, sued hotel owner Henry Kallan and the Library Hotel Group over a copyright infringement, but they settled and allowed the hotel to continue as is, providing a unique travel experience for book lovers visiting New York.

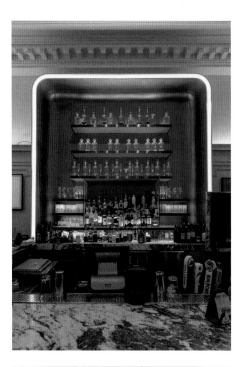

ABOVE A plaque commemorates the legendary Algonquin Round Table.

TOP The Blue Bar, fully stocked for cocktails.

RIGHT Today the Blue Bar restaurant and lounge mixes old and new.

THE ALGONQUIN HOTEL
59 WEST 44TH STREET

The Algonquin Hotel was built in midtown Manhattan by architect Goldwin Starrett for the Puritan Reality Company. It opened in 1902 with 181 rooms over twelve floors behind a Renaissance Revival facade inspired by the Beaux-Arts style. The hotel was originally called The Puritan and built to house long-term tenants, but they were few and far between in the early years. When Frank Case, one of the original employees, took over as manager in 1907, that began to change. He adjusted the operating plan to that of a regular hotel, and worked to draw in artists, performers, and writers from the newly developing Theatre District near the hotel around Times Square. The Algonquin became a destination for actors and writers. Guestbook entries include H.L. Mencken, Gertrude Stein, Mary Chase, William Inge, and Arthur Miller. It was one of the first hotels where women could stay alone, and was said to offer authors a night at the hotel in exchange for a signed book. The hotel housed multiple restaurants over the years, including the Pergola Room (which later became the Oak Room), the Rose Room, and eventually the Blue Bar. Both the Pergola Room and Rose Room welcomed the members of the Vicious Circle, also known as the Algonquin Round Table, a group of writers who met there for lunch every day between 1919 and 1929. They included Dorothy Parker, Robert Benchley, Ruth Hale, and Pulitzer-Prize recipients George S. Kaufman, Robert E. Sherwood, and Marc Connelly. Frank Case bought the hotel in 1927, and he owned and managed it until he passed away in 1946. Since then, the hotel has been bought and sold multiple times, and is currently a part of the Autograph Hotel Group. Visitors can order a $10,000 martini and bask in the history and hospitality of early-twentieth-century New York.

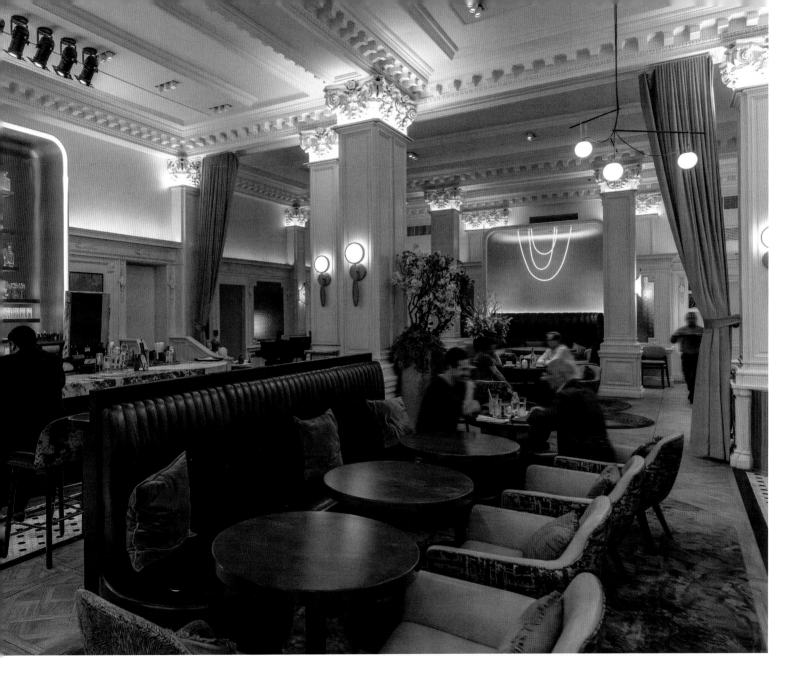

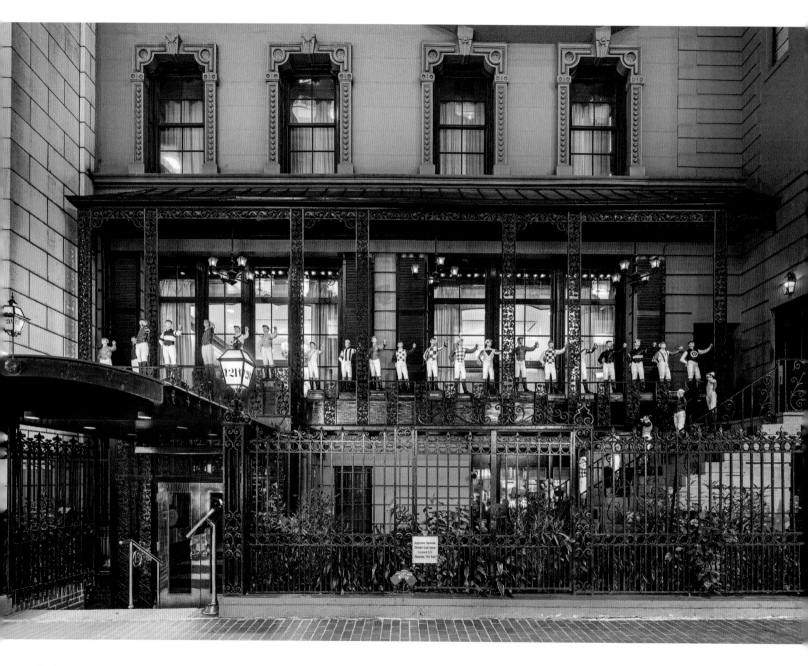

LEFT The 21 club was one of the most well-known speakeasies of the Prohibition era.

RIGHT The famous jockey figurines were gifted by wealthy patrons.

21 CLUB

21 WEST 52ND STREET

21 Club, also known as 21, began as a speakeasy located at 21 West 52nd Street. It opened in the middle of Prohibition in 1929, and served alcoholic beverages while it was illegal to do so. It also allowed politicians, celebrities, and gangsters the chance to have a luxurious night out in a unique and fancy location with elegant decor, including famous jockey figurines and toys hung from the ceiling. 21 Club had secret wine cellars and a complex warning system for police raids, which allowed the bartenders to dump alcohol directly into the city sewer system before it could be discovered. 21 was frequented by Dorothy Parker, Truman Capote, and J.D. Salinger, the latter of whom included 21 in the text of *The Catcher in the Rye*. 21 Club survived long beyond the repeal of Prohibition, serving guests as a nightclub and restaurant until 2020, when it closed after ninety years.

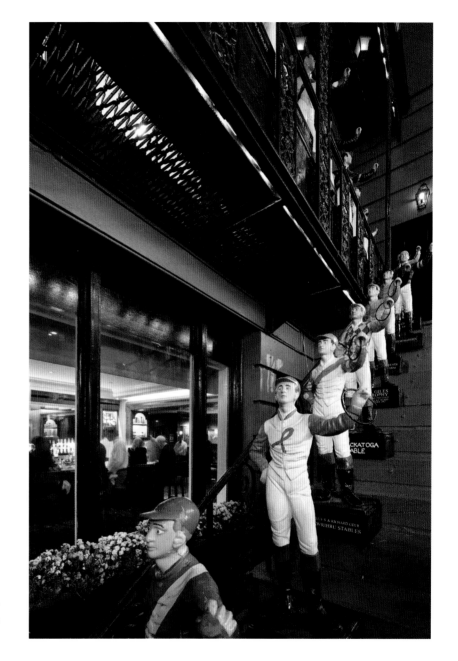

CHUMLEY'S

86 BEDFORD STREET

Chumley's was a Greenwich Village bar that opened in 1922 and closed in 2020. During this time, it hosted many famous writers, including E.E. Cummings, William Faulkner, Eugene O'Neill, and Willa Cather, among others. Edna St. Vincent Millay was rumoured to have tended the bar there on occasion. Located between Bedford and Barrow streets, Chumley's had two entrances, a trap door, and a secret staircase that helped patrons escape during Prohibition-era police raids. The clandestine vibe made it a favourite for journalists, activists, and novelists who went against the mainstream, like the writers of the Lost Generation and the Beat Generation.

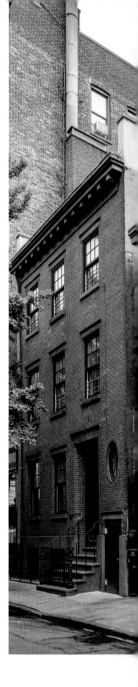

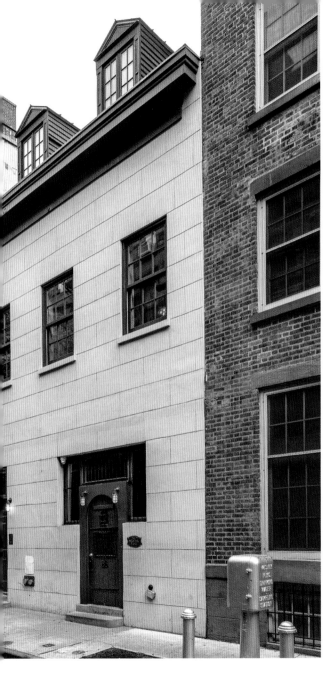
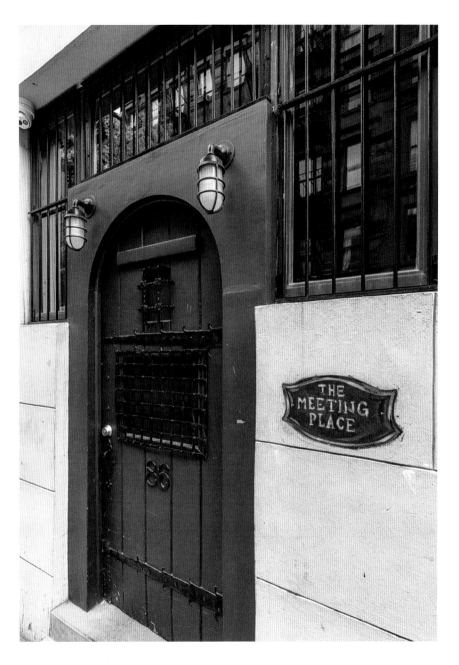

RIGHT The first dedicated cigar bar to debut in New York.

BOTTOM RIGHT Books line the walls of this unique literary drinking spot.

FAR RIGHT The outdoor seating is popular in summer.

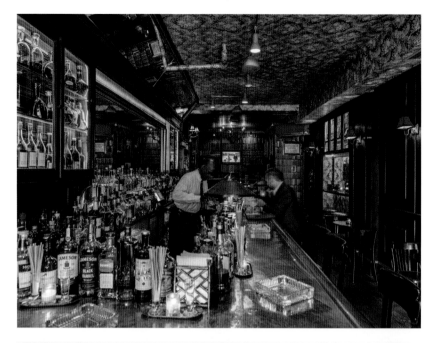

HUDSON BAR AND BOOKS

636 HUDSON STREET

Hudson Bar and Books opened in 1991 in Greenwich Village. It is the bar for literature lovers thanks to its library-core aesthetic and walls loaded with books. It's known for being quiet enough to read a great novel while enjoying a drink and a cigar. The cosy haunt also has bowtie-wearing bartenders, creative appetizers, a sophisticated cocktail menu, a humidor full of cigars, and live jazz on the weekends.

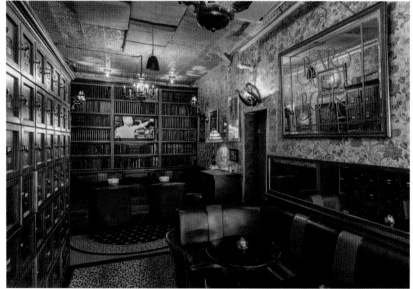

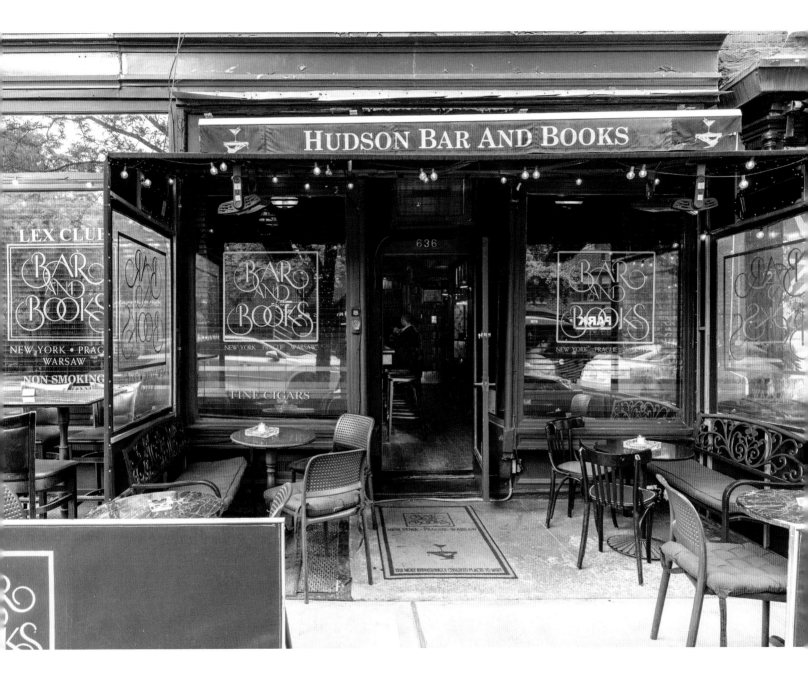

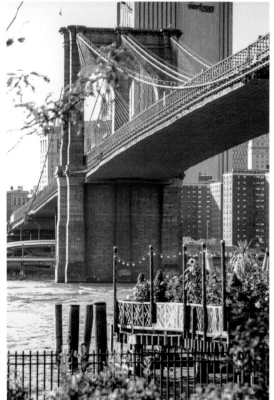

LEFT A view from within The River Café towards Manhattan through cocktail glasses.

BOTTOM LEFT The waterfront location has impressive views of Brooklyn Bridge.

RIGHT One of New York's most unique locations, the restaurant is an oasis in the city.

THE RIVER CAFÉ

1 WATER STREET (BROOKLYN)

Opened in 1977 by restaurateur Michael O'Keeffe, Brooklyn's Michelin-starred The River Café has been a dichotomy since day one. It occupies a converted nineteenth-century warehouse right on the water, offering breathtaking views of the Manhattan skyline and the Brooklyn Bridge, blending old-world charm with culinary sophistication. When O'Keeffe first pitched the idea of the restaurant, there was no ferry service and the area was forgotten and abandoned, full of empty waterfront warehouse buildings and nothing but possibilities. In spite of the challenges of the location, O'Keeffe's gamble worked. The restaurant has been serving customers for four decades, and has been decorated with accolades from the Restaurant Hall of Fame to the Wine Spectator guide, and the French culinary guide Gault&Millau, which named it one of the five best restaurants in New York. The River Café has played a part in the success

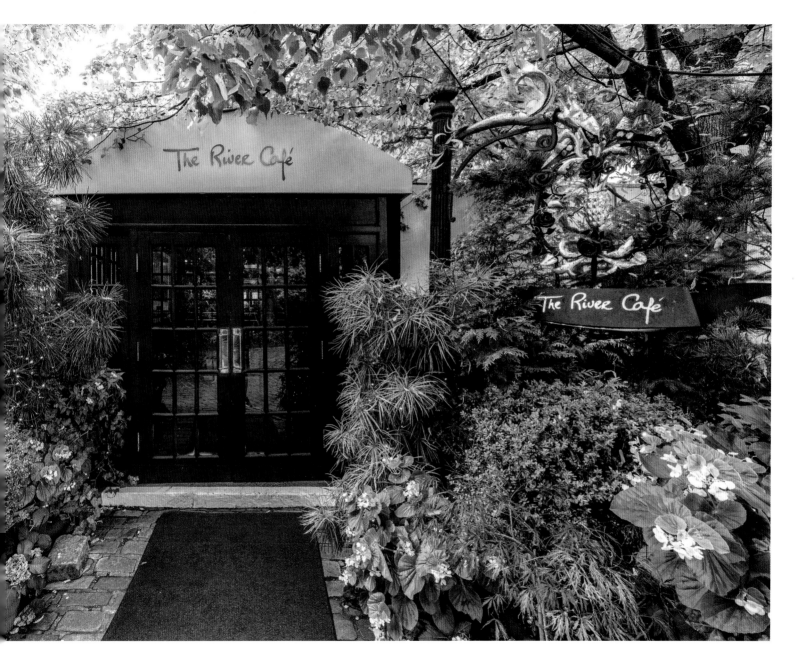

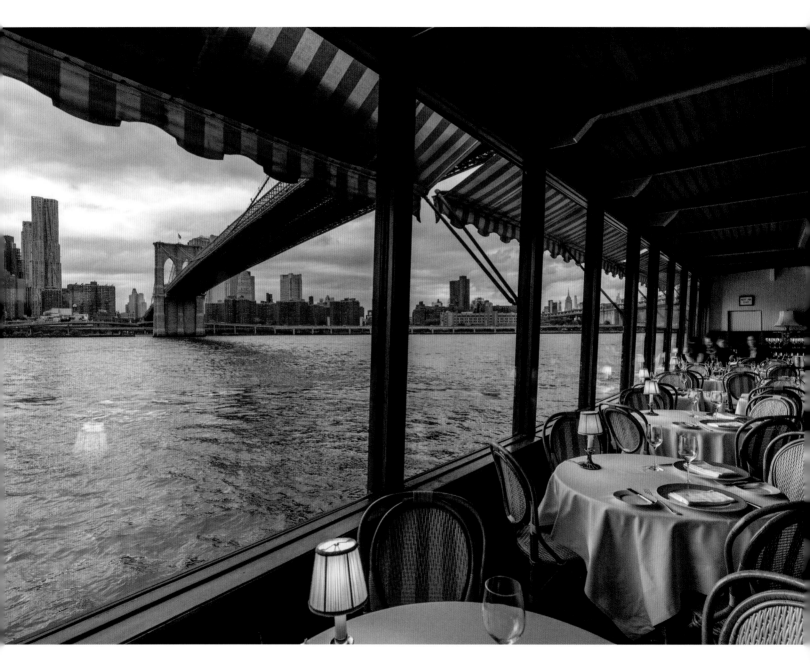

LEFT Views across the water to the Manhattan skyline.

RIGHT Beautiful gardens surround the café at the base of the Brooklyn Bridge.

BOTTOM RIGHT The restaurant boasts a Michelin star, as well as one of the finest views in the city.

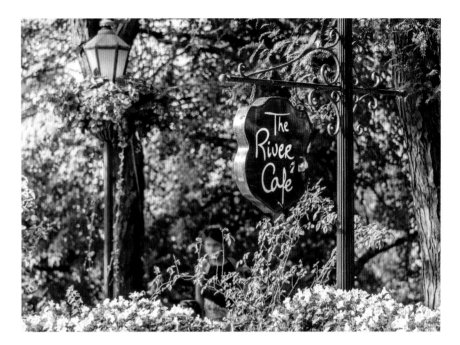

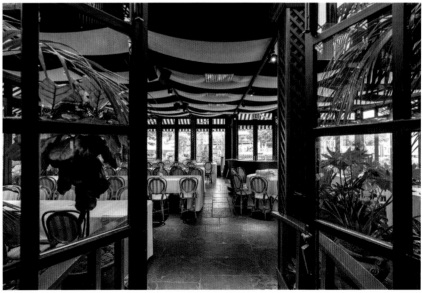

of the area that surrounds the restaurant which has gentrified with the name DUMBO, an acronym that stands for Down Under the Manhattan Bridge Overpass. Today, it is once again easily accessed by ferry.

Bret Easton Ellis included it in his 1991 book *American Psycho*, as one of only a few stops main character Patrick Bateman made in Brooklyn. Its inclusion highlighted the booming economy and rampant social inequalities in Manhattan. It represented more than just a dining destination with a great view, suitable for Patrick Bateman's affluent lifestyle and quest for validation. While the restaurant's elegant facade and exquisite cuisine suggested opulence and refinement, a scratch just beneath the surface exposed a dark undercurrent of violence and moral decay, symbolic of Bateman himself.

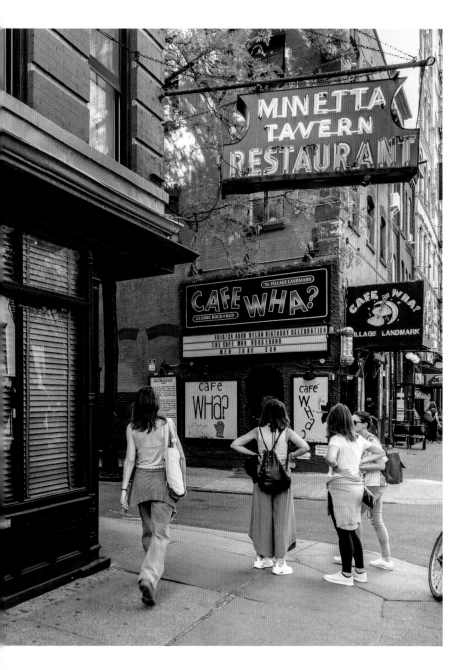

MINETTA TAVERN

113 MACDOUGAL STREET

Minetta Tavern was named after the creek that used to flow
for two miles through Manhattan, originating at Washington
Square Park and running north close to the MagDougal-
street spot. Since opening in the 1930s, the tavern has drawn
creative types from all over the Village, including writers Ernest
Hemmingway, Ezra Pound, and Dylan Thomas. Joe Gould, a
reporter at the *New York Evening Mail* and author of *An Oral
History of the Contemporary World* – said to be the world's
longest book at the time-spent so much time at the tavern that
he got his mail delivered there. While there is still a bustling bar
scene, today's Minetta Tavern is equally known for its menu of
French-inspired comfort food.

RIGHT The luxurious fine-dining restaurant has featured in great twentieth-century novels.

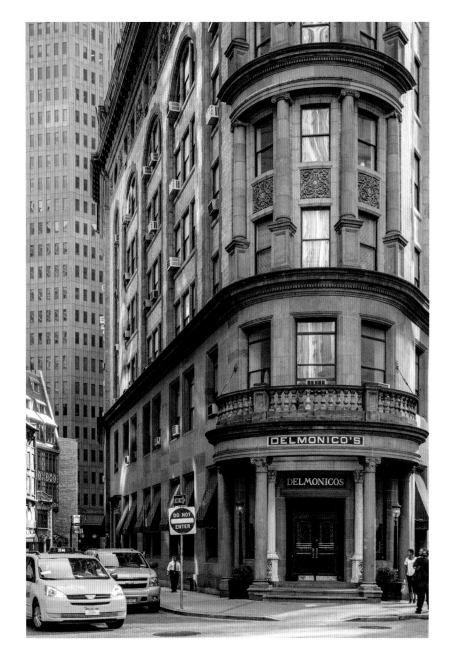

DELMONICO'S
56 BEAVER STREET

The original Delmonico's opened in 1827 as a bakery, and slowly morphed into the first fine-dining establishment in New York City. It was the very definition of 'New American' haute cuisine, reshaping the luxury restaurant scene in America with French-inspired dishes, private dining rooms, and a thousand-bottle wine cellar. The original building burned down in 1835 but was quickly replaced in 1837 with the new location situated at 56 Beaver Street, at the intersection of Beaver, William, and South William. Delmonico's was the go-to for fancy dinners honouring literary greats of the time, including Mark Twain, Washington Irving, and Charles Dickens. It was featured in Edith Wharton's Gilded Age novel *The Age of Innocence*, and in E. L. Doctorow's *Ragtime*, set in the early twentieth century. In 2023, a new Delmonico's opened complete with [inventor, Nikola] Tesla's Quarters and Dickens Alcove, named after certain visitors of the past.

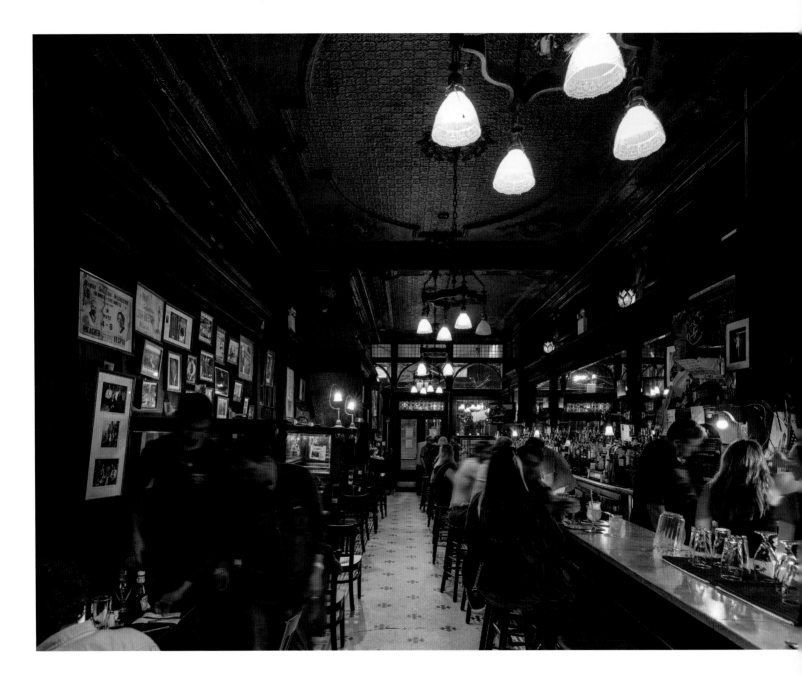

LEFT New Yorkers have enjoyed cocktails in the Old Town Bar since 1892.

RIGHT Lots of the original features have been preserved.

BOTTOM RIGHT The vintage booths have seated many award-winning writers.

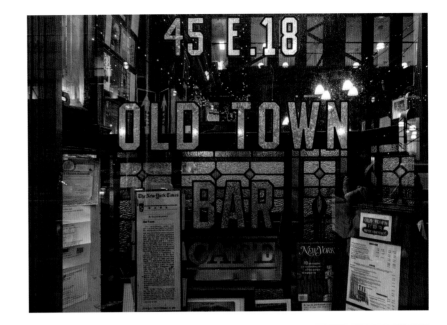

OLD TOWN BAR

45 EAST 18TH STREET

This 18th-street watering hole has been open since 1892, making it one of the oldest bars in the city. It did close for a period of time, but even with interruptions, it managed to hold on to many key original details like the seventeen-metre-(fifty-five-feet-) long bar, five-metre- (sixteen-feet-) high ceilings, bevelled mirrors, and a working dumbwaiter for bringing food from the kitchen to the dining areas. When it first opened, women were allowed to go to the second-floor dining room only, and it was a big deal when equal access was finally granted to the whole property. Pulitzer Prize-winner Frank McCourt, Seamus Heaney, Thomas Kelly, and Nick Hornby are just some of the writers who logged hours in the vintage booths and on the barstools, enjoying cocktails and tasty menu offerings, and the unique opportunity to go back in time to a vintage New York.

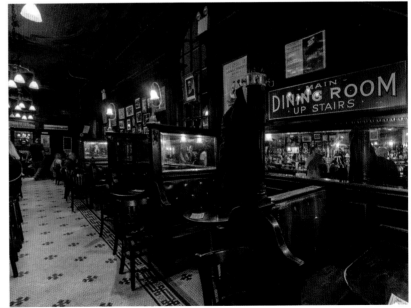

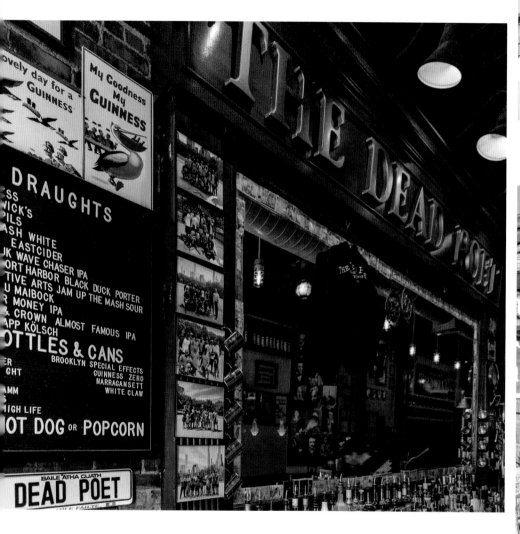

The following text appears on the sign in the image:

lovely day for a GUINNESS

My Goodness
My GUINNESS

DRAUGHTS

...SS
...WICK'S
...PILS
...ASH WHITE
... EASTCIDER
...UK WAVE CHASER IPA
...ORT HARBOR BLACK DUCK PORTER
...TIVE ARTS JAM UP THE MASH SOUR
...U MAIBOCK
...R MONEY IPA
...R CROWN ALMOST FAMOUS IPA
...APP KÖLSCH

...OTTLES & CANS
Brooklyn SPECIAL EFFECTS
...R GHT GUINNESS ZERO
NARRAGANSETT
WHITE CLAW
...MM
...HIGH LIFE

...OT DOG OR POPCORN

BAILE ÁTHA CLIATH
DEAD POET

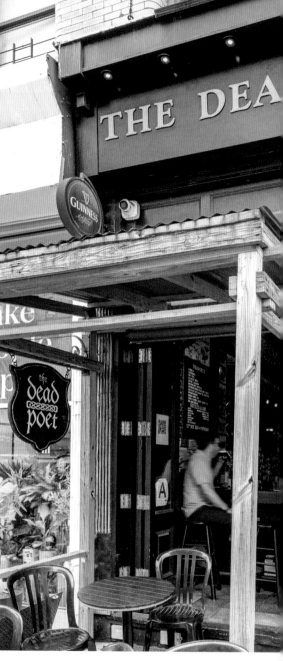

ABOVE The Upper West Side bar celebrates all things Irish and literary.

RIGHT The Dead Poet attracts readers, writers, and Guinness-drinkers alike.

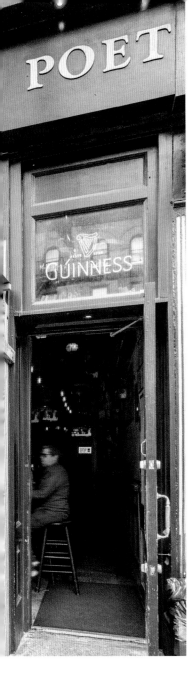

RIGHT Photographs of celebrated writers on the wall.

BOTTOM RIGHT The Dead Poet claims to pour one of the finest pints of Guinness in NYC.

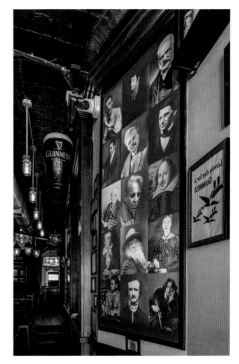

THE DEAD POET

450 AMSTERDAM AVENUE

In the year 2000, a high-school English teacher named Drew Dvorkin opened a bar that combined his love of literature and friendly Irish pubs, and The Dead Poet came to be. He wanted a space that celebrated writers and writing, so he covered the walls with photographs, quotes, and poems, and stocked the shelves with classics books that can be borrowed. Located near Columbia University, Barnard College, and City College New York, The Dead Poet welcomes writers and readers at all stages: students, professors, and professional writers, who all want to spend their time pairing words and whiskey on the Upper West Side.

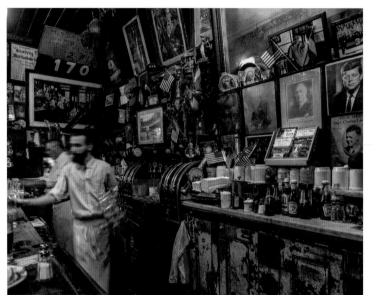

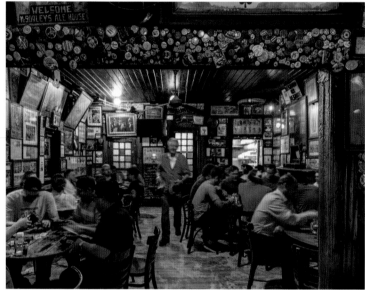

McSORLEY'S OLD ALE HOUSE
15 EAST 17TH STREET

McSorley's Old Ale House opened in 1854, and weathered the Civil War, Prohibition, and the Women's Liberation Movement with little change to its sawdust floors, scratched wooden tables, and curated menu. This cash-only business in the East Village didn't let women in until they were sued in 1969, but that's the only significant change visitors are likely to notice. McSorley's has served two kinds of ale – dark and light – since its opening, along with a small handful of snacks and sandwiches. The selections, like cheese and crackers and liverwurst, are as nostalgic as the decor, but folks don't come here for the food. McSorley's has welcomed regulars and tourists, labourers and intellectuals for 170 years. Presidents including Abraham Lincoln and Teddy Roosevelt are said to have visited, as well as celebrities like Harry Houdini and Woody Guthrie. Many writers, including E.E. Cummings, Hunter S. Thompson, and John Sloan enjoyed cocktails and community here over the years. Joseph Mitchell wrote a series of stories for the *New Yorker*, along with a book called *McSorley's Wonderful Saloon*, published in 1943. By all accounts, Mitchell would find the place remarkably unchanged if he returned for an ale today.

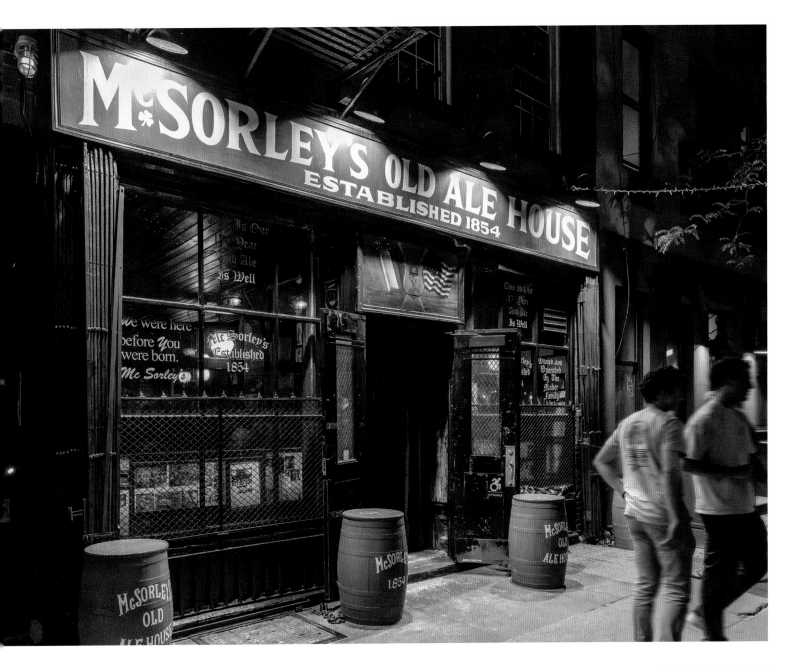

Give me such shows — give me
the streets of Manhattan!

WALT WHITMAN

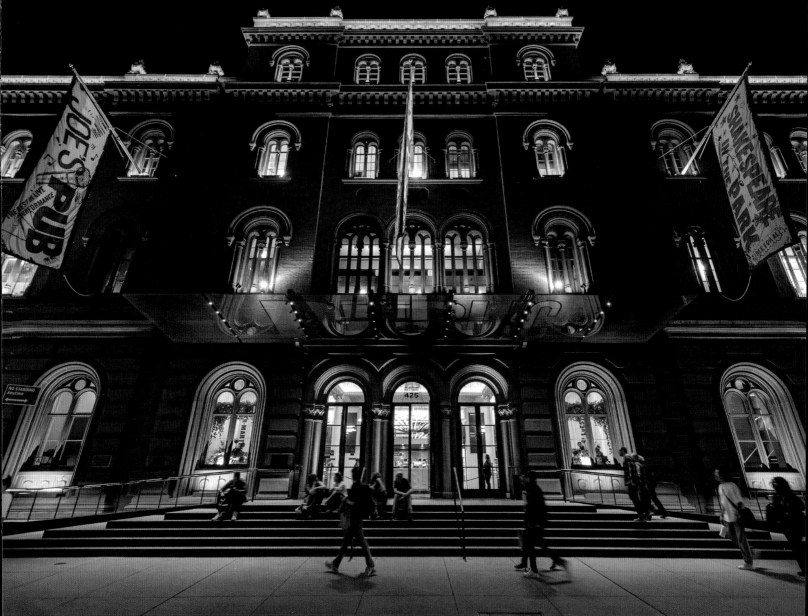

THEA

TRES

RIGHT A plaque dedicated to John Golden on the wall of the theatre.

BOTTOM RIGHT John Golden Theatre is one of the smallest on Broadway.

FAR RIGHT Set in the heart of the Theatre District in Midtown Manhattan, this venue was designed in the Spanish style.

JOHN GOLDEN THEATRE

252 WEST 45TH STREET

John Golden Theatre was originally called the Theatre Masque, before legendary producer John Golden put his own name on it in 1936. Built in 1927 by real estate magnet Irwin Chanin and architect Herbert J. Krapp, the John Golden Theatre is one of Broadway's most intimate sites with only 800 seats. While its audience capacity is small, its architectural and design details rival any of the five larger theatres that were erected by Chanin's company. Built in the Spanish style, with terracotta bricks, arches, and a loggia, the same style continues with details around the stage and in the audience and the balconies. The small size makes for an intimate audience experience and lends itself to quieter dramas with small casts. Notable works making their Broadway debuts at John Golden Theatre include Tennessee Williams' *The Glass Menagerie* in 1944, Arthur Miller's *Death of a Salesman* in 1949, David Mamet's Pulitzer Prize-winning *Glengarry Glen Ross* in 1984, and the more recent *Slave Play* by Jeremy O. Harris in 2018, which won more Tony nominations than any play before it.

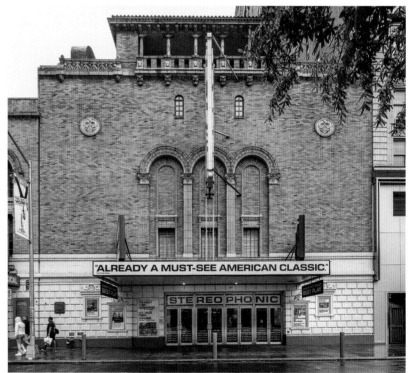

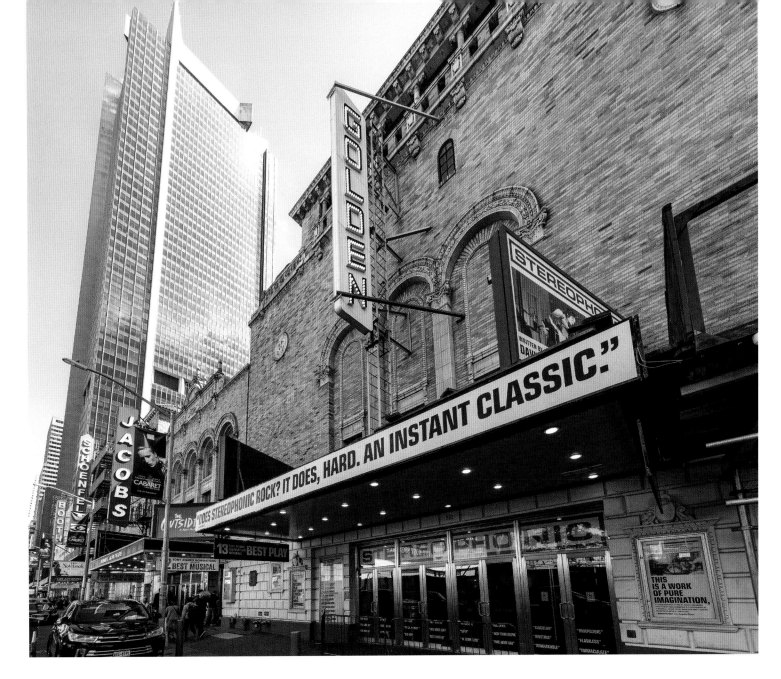

EUGENE O'NEILL THEATRE

230 WEST 49TH STREET

Eugene O'Neill Theatre is named after the great American playwright in honour of his numerous contributions to American theatre. Built by Irwin Chanin with architect Herbert J. Krapp for the famous Shubert family, it was originally called The Forrest Theatre after noted actor Edwin Forrest when it opened in 1925. It became the Coronet Theatre in 1945 and then the Eugene O'Neill in 1959 to honor O'Neill posthumously. While he had four Pulitzer Prizes for Drama, and a Nobel Prize for Literature, O'Neill never had a play make its Broadway debut at the theatre.

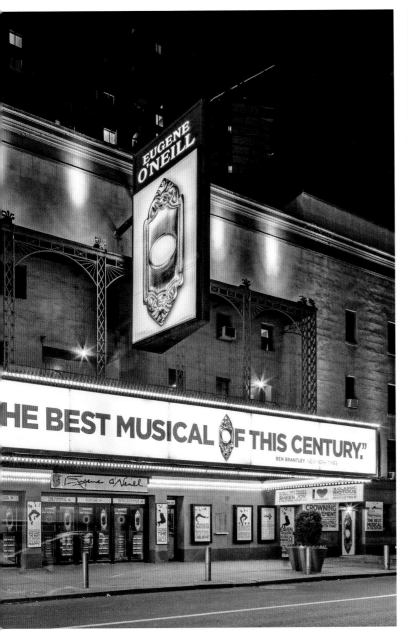

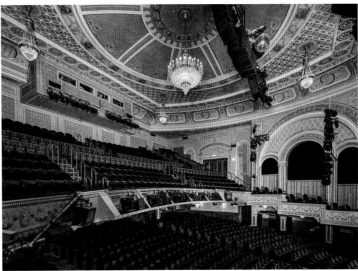

TOP The stunning interior of the theatre.

ABOVE The detailed decorative handrails.

LEFT The theatre is named after the American playwright.

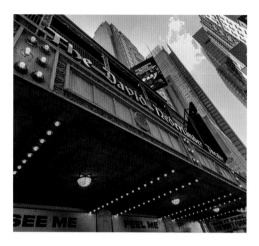

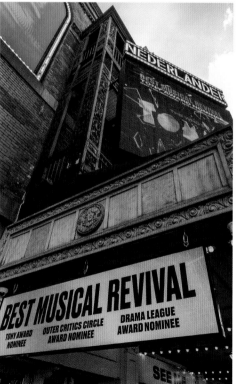

LEFT AND BOTTOM LEFT The theatre is situated in the Times Square Theatre District.

RIGHT The red-brick building has an ornate fire escape above the main doors.

NEDERLANDER THEATRE

208 WEST 41ST STREET

Nederlander Theatre has gone by many names since opening as the National Theatre in 1921, including Billy Rose Theatre, and Trafalgar Theatre. It started life as a carpentry shop and then Walter C. Jordan converted it into a theatre for less than $1 million, keeping the building's rustic charm inside and out, with woodworking designs instead of the more popular plaster. The first play performed here was Sidney Coe Howard's *Swords* in 1921. While Howard went on to win a Pulitzer for *They Knew What They Wanted* in 1925, his debut *Swords* bombed with critics and audiences alike. Luckily, the next show was John Willard's *The Cat and the Canary*, which impressed Broadway literati and audiences, running for nine months. Thus began a long history of launching world-famous plays, including *Grand Hotel*, based on the book by Vicki Baum, Lillian Hellman's *The Little Foxes*, and Edward Albee's *Who's Afraid of Virginia Woolf*. Jonathan Larson picked the Nederlander for *Rent*'s Broadway debut in 1996, choosing the theatre because of its dilapidated charm, which matched the setting for the musical. *Rent* ran for eight years and more than 5,000 performances, making it the longest-running hit for the house.

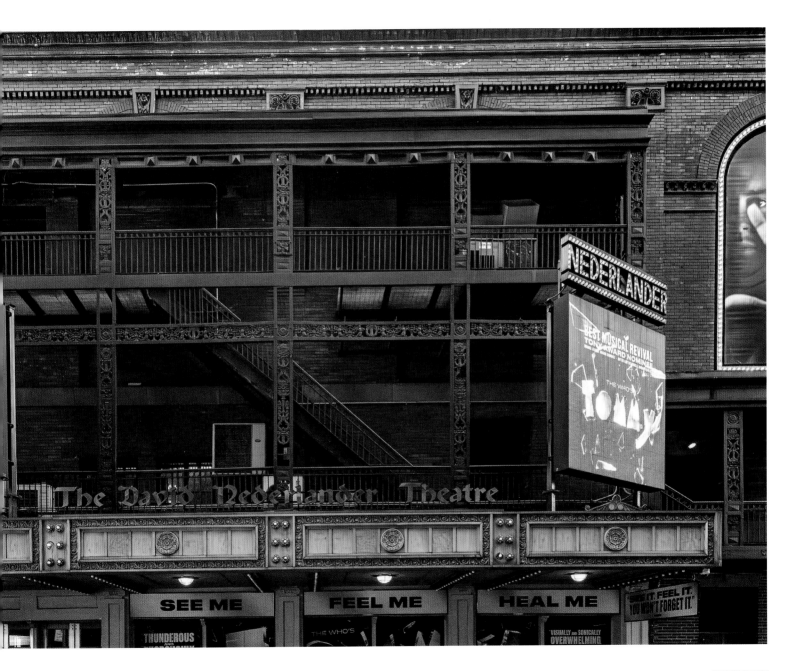

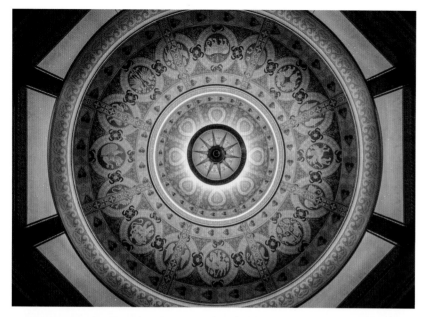

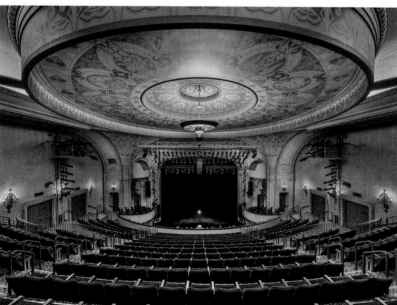

AL HIRSCHFELD THEATRE

302 WEST 45ᵀᴴ STREET

A l Hirschfeld Theatre was originally called Martin Beck Theatre, named after the Vaudeville performer turned theatre-owner and producer. Martin Beck booked talent all over the US and Europe, and was well known for bringing Harry Houdini to theatres around the country and changing the course of the magician's life. The Hirschfeld Theatre was Beck's second theatre, and notable as the only Broadway house done in a Byzantine style, where the auditorium and stage house share a design theme. Today, both the facade and interior are on the register of New York City landmarks, and the theatre is run by Jujamcyn Theatres. It was renamed in 2002 after the visual artist Al Hirschfeld who was known for caricatures of Broadway shows and performers, and whose illustrations adorned the walls inside. The theatre supported a myriad of well-known Broadway debuts, including *Dynamo* and *The Iceman Cometh* by Eugene O'Neill, *The Rose Tattoo* by Tennessee Williams, and *The Crucible* by Arthur Miller.

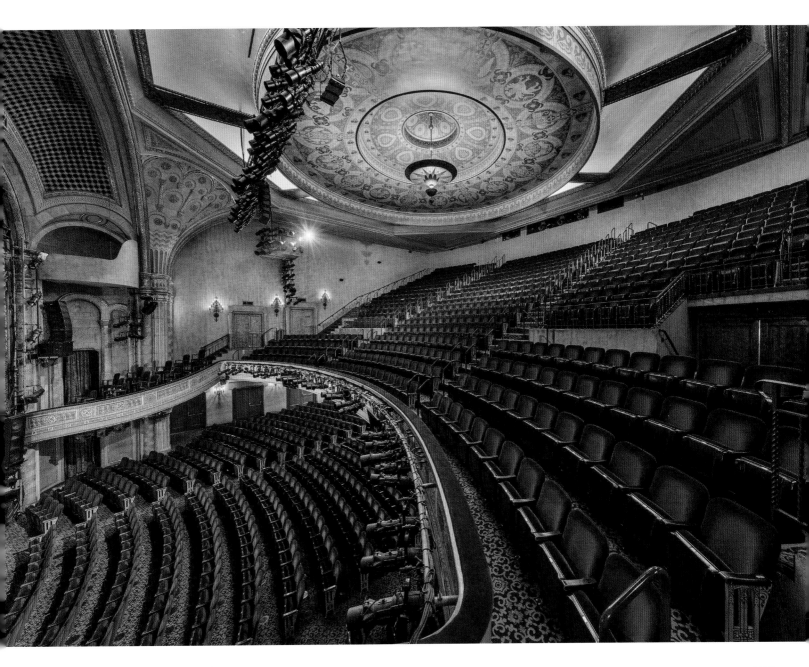

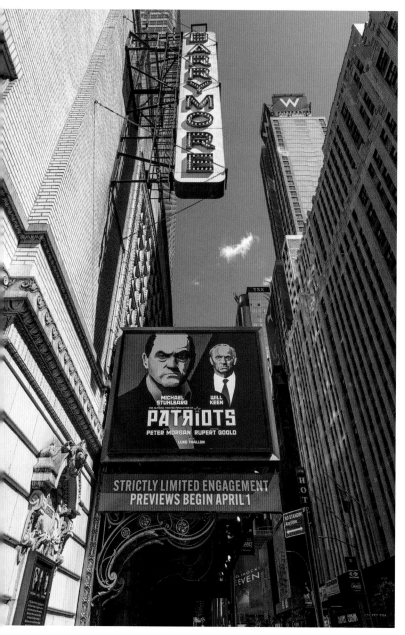

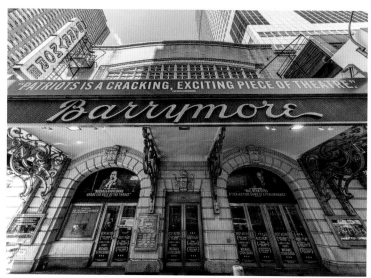

LEFT The theatre is situated in the heart of the Theatre District in Midtown Manhattan.

TOP It was named after actress Ethel Barrymore.

ABOVE Engraved wreath above the signboard.

RIGHT The theatre with its detailed facade is a New York City landmark.

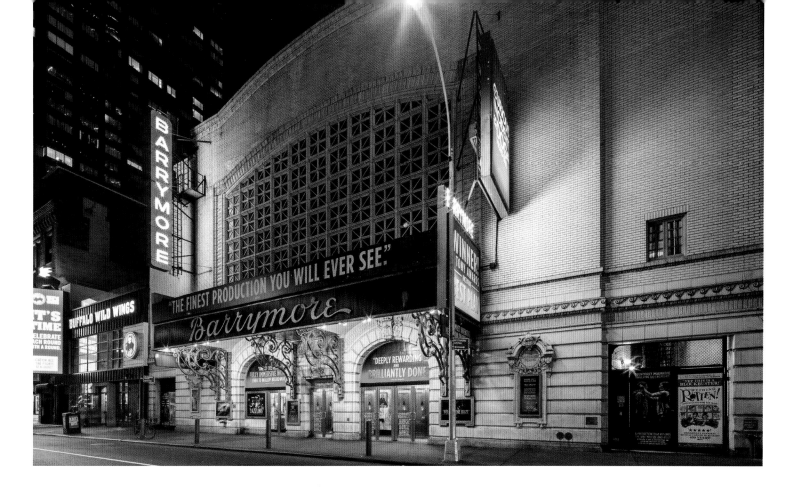

ETHEL BARRYMORE THEATRE

243 WEST 47TH STREET

The famous Shubert brothers commissioned architect Herbert J. Krapp, who designed half of the Broadway theatres, to take on Ethel Barrymore Theatre. He was known for marrying interior and exterior design, and maximizing space for better sight lines and bigger, more luxurious seats. The Barrymore opened in 1928, named for the actress who had agreed to be represented exclusively by the Shubert brothers. The first play was G. Martinez Sierra's *The Kingdom of God*, starring Barrymore. Other early notable debuts include *The Women* by Clare Boothe Luce, *Design for Living* by Noël Coward, *A Raisin in the Sun* by Lorraine Hansberry, and *A Streetcar Named Desire* by Tennessee Williams.

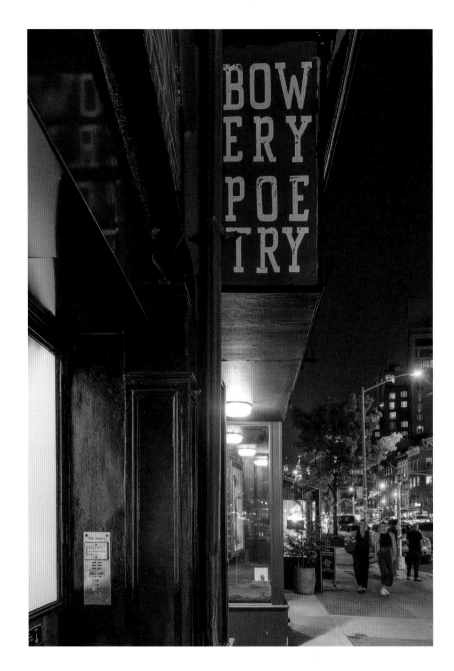

BOWERY POETRY CLUB

308 BOWERY

Since 2002, Bowery Poetry Club has been serving beats of the spoken word variety. Founded by poet Bob Holman, this space hosts spoken word artists for poetry slams and open mic nights, as well as ongoing series based around specific themes, languages, and genres. Nestled in the East Village, the club features first timers along with notable and experienced voices. Taylor Mead did a performance there every Friday night for years, and his poetry book called *A Simple Country Girl* was the first book to be published by Bowery Poetry Books, a publishing imprint started in partnership with the club. Other notable writers featured there include Janet Hamill, Saul Williams, and Patricia Smith. Today, Bowery Poetry Club continues to stand out as a unique, immersive literary experience, with events that celebrate poetry and the community of artists who write it.

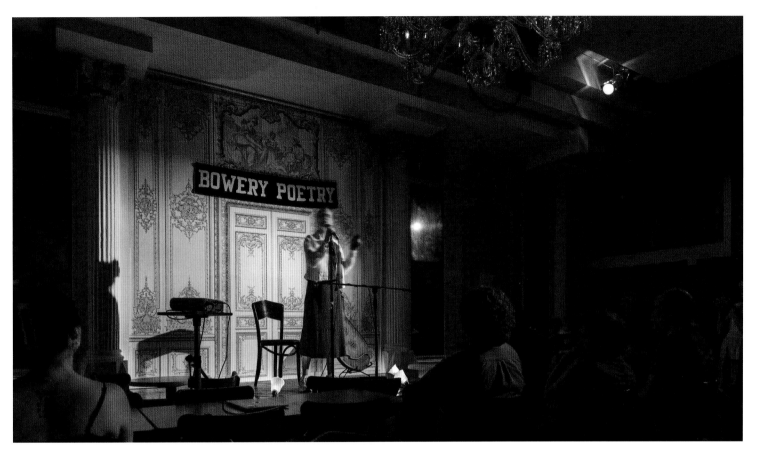

ABOVE Open mic nights are held regularly.

LEFT AND FAR The esoteric window display which faces the street opens to reveal a giant poem adorning the walls of the entry hall.

"

The most wonderful street in the universe is Broadway. It is a world within itself. High and low, rich and poor, pass along at a rate peculiar to New York, and positively bewildering to a stranger.

FRANK RICH

NUYORICAN POETS CAFÉ
236 EAST 3ᴿᴰ STREET

Founded in 1973, the Nuyorican Poets Café has offered a place for multicultural artists and residents in New York to come together to share ideas and authentic and personal truths that were often missing from mainstream literary places. Born from the Nuyorican (New York and Puerto Rican) literary tradition, Puerto Rican and Latino poets and spoken word artists brought their unique perspective to the stage, engaging audiences with emotional lyrical performances in Spanish and English. Performers have included co-founders Miguel Algarín, Miguel Piñero, and Pedro Pietri, along with Victor Hernández Cruz, Diane Burns, Tato Laviera, Piri Thomas, Jesús Papoleto Meléndez, Sandra María Esteves, and José Angel Figueroa. In 1980, they purchased the space on 3rd Street and made it a café. They've launched generation after generation of writers, and provided a performance space for Latin musicians and artists of all kinds. In 1994, there was a documentary called *Nuyorican Poets Café*, which won its category at the 1995 New Latino Filmmakers Festival In LA. Two years later, Nuyorican Poets Cafe's Slam Team was featured in a documentary called *SlamNation*, bringing national attention to the Lower East Side space. Audiences and performers have flocked there steadily since. In 2024, the New York City Department of Cultural Affairs and the Department of Design and Construction began a multi-million-dollar renovation of the Nuyorican Poets Café. The reimagined space is set to open again in 2026 with two theatres, a larger lobby, an elevator, a flexible classroom space, and room for multiple concurrent performances.

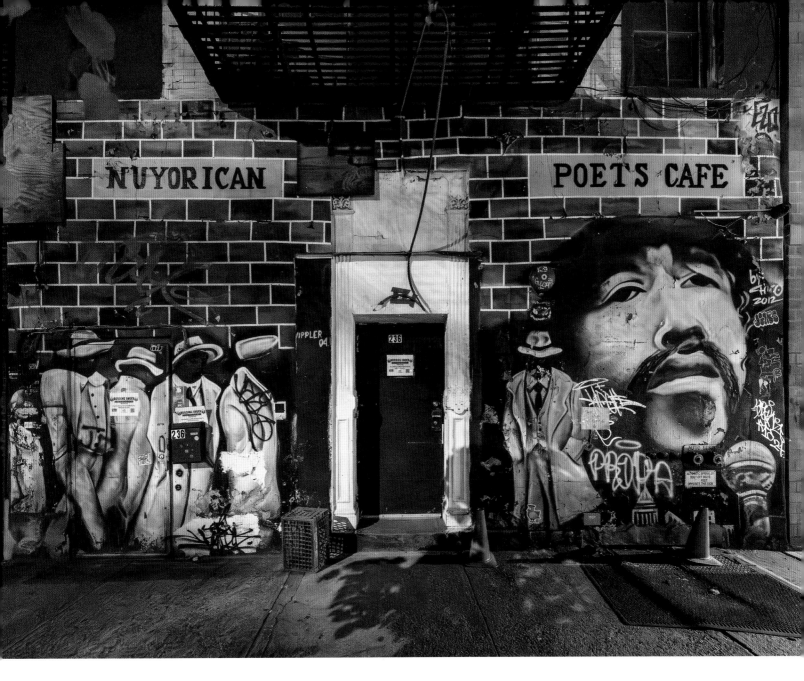

The city seen from the Queensboro Bridge is always the city seen for the first time, in its first wild promise of all the mystery and the beauty in the world.

F. SCOTT FITZGERALD

The Great Gatsby

New York, you are an Egypt! But an Egypt turned inside out. For she erected pyramids of slavery to death, and you erect pyramids of democracy with the vertical organ-pipes of your skyscrapers all meeting at the point of infinity of liberty!

SALVADOR DALÍ

LITERARY

LOCATIONS

THE METROPOLITAN MUSEUM OF ART

1000 5TH AVENUE

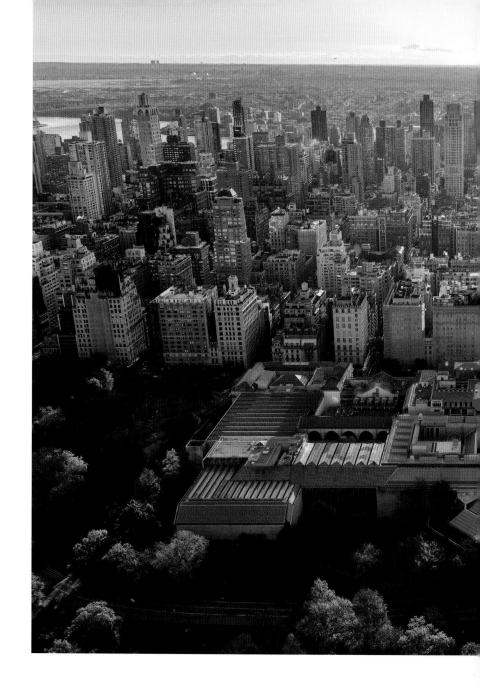

The Metropolitan Museum of Art, also known as The Met, is full of creative inspiration through the ages, including textiles, furniture, paintings, artefacts, illustrated books, and more. Its enduring presence in literature has inspired many storytellers. Edith Wharton's Pulitzer Prize winner *The Age of Innocence*, published in 1920, follows the main characters, Newland Archer and his wife May, to the museum, which serves as a backdrop for their internal conflicts, and underscores the themes of tradition, repression, and desire that flow through the novel. The Met got a starring role in *From the Mixed-Up Files of Mrs. Basil E. Frankweiler*, E.L. Konigsburg's Newbery Medal-winning children's book of 1967, which takes readers all over the museum with two precocious pre-teens, who run away from home, move into the Met, and get caught up in a mystery about a sculpture that may have been carved by Michelangelo. The Met makes a most-dramatic appearance as the scene of the inciting incident in Donna Tartt's Pulitzer Prize-winning *The Goldfinch*, and is a backdrop for the main character's search for the meaning of life in the aftermath of tragedy.

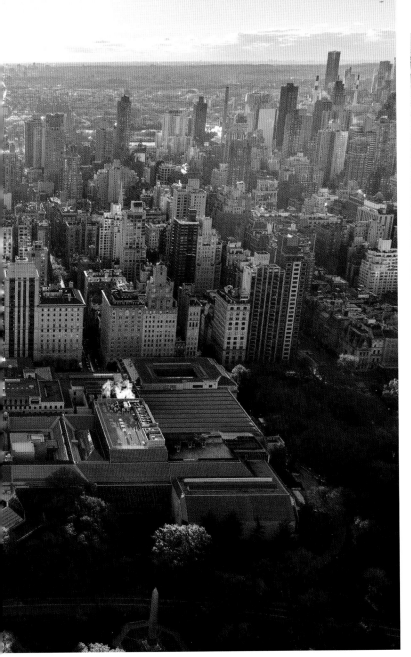

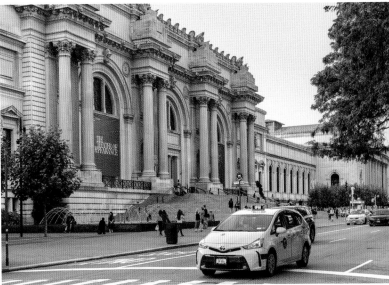

LEFT The Met is one of the largest museums in the world.

ABOVE The building has expanded as the collections have grown.

TOP The main entrance on 5th Avenue.

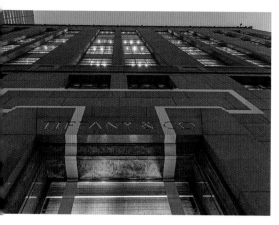

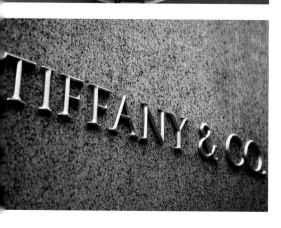

TOP The building, with its marble facade, is a New York City landmark.

MIDDLE The close up of the steel doors.

BOTTOM The iconic Tiffany & Co sign.

TIFFANY & CO

727 5ᵀᴴ AVENUE

The celebrated store was famous for jewellery and luxury goods long before Truman Capote's *Breakfast at Tiffany's* was published in 1958. Tiffany & Co was founded in 1837 by Charles Lewis Tiffany as a stationery and luxury goods emporium. By 1857, the focus had shifted to jewellery. Charles's son, Louis Comfort Tiffany, took over as artistic director in the early twentieth century, and reprioritized the company to focus on jewellery and sterling silver. From the start, the store prioritized the transparency of pricing and cash sales, which was unusual compared to similar stores at the time. It made for a more relaxing shopping experience, inspiring Capote's book. The location serves as a place of refuge and inspiration for main character Holly Golightly, who views it as a sanctuary amid the chaos of her life. She spends a few moments in the morning having breakfast by herself in front of the luxurious store windows. The simple act juxtaposes Holly's glamorous exterior with her inner turmoil, and underscores the themes of escapism and alienation that define the book. In 2023, Michelin-starred chef Daniel Boulud opened Blue Box Café serving breakfast, high tea, and private dinners, allowing visitors to enjoy Breakfast at Tiffany's without the existential ennui.

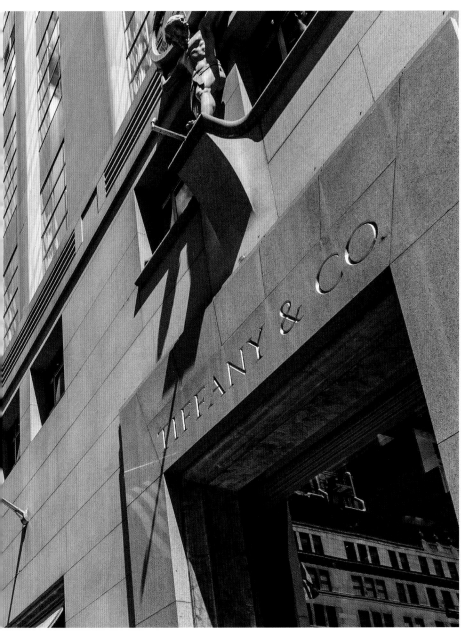

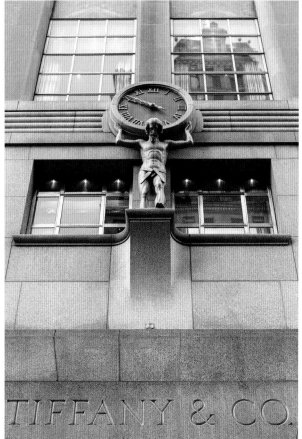

LEFT The flagship store opened in 1905.

ABOVE The statue and clock are the
only sculptures on the facade.

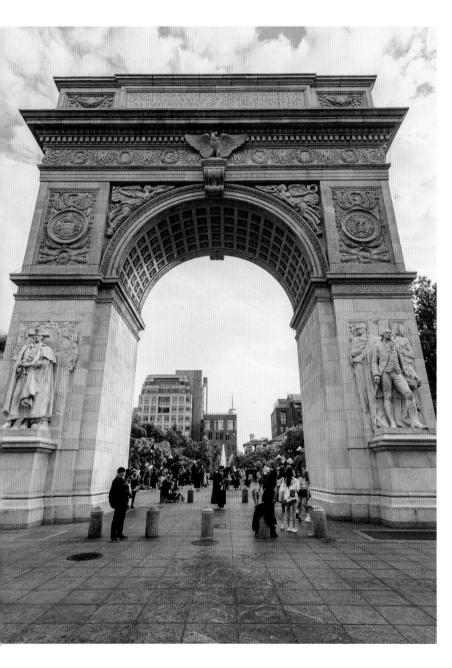

WASHINGTON SQUARE PARK

1 WASHINGTON SQUARE PARK

Washington Square Park has served as a cultural touchpoint and historical landmark in Greenwich Village since Alderman Abraham Valentine decided to take a potter's field and transform it into a military parade ground in 1826. For most of the nineteenth century, the city added features and details to the inside of the park, culminating in 1889, when a magnificent memorial arch was erected to commemorate the centennial of George Washington's inauguration as first President of the United States. Both Robert Louis Stevenson and Mark Twain immortalized the park in essays, sharing stories of riding the donkeys who entertained park visitors. Twain's essay *The Innocents Abroad*, published in 1869, focuses more on the park's historical role as a place of entertainment and leisure. Stevenson's travelogue *Across the Plains*, published in 1892, allows readers a glimpse into the whimsy and fun available in the park. Washington Square Park is mentioned in J.D. Salinger's *Catcher In The Rye*, as a place that Holden Caulfield goes to rest and reflect on his time in New York. It's also featured in *Washington Square*, the Henry James novel published in 1880 that explores the pressures of societal expectations and the tensions of a bustling urban environment. Overall, the work written about it proves that the park itself is more than just a physical setting, it's a symbol of the social conformity required at the time, and the place where New Yorkers went to escape.

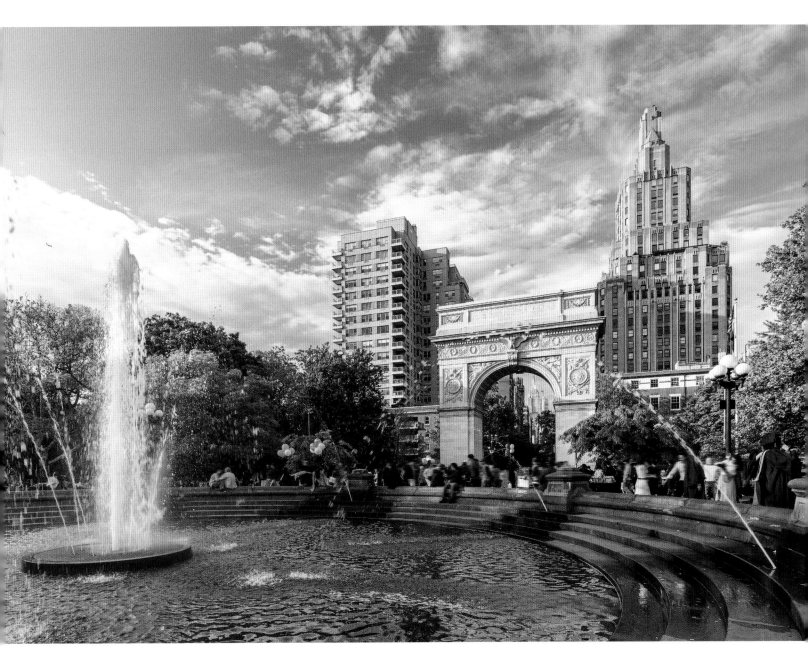

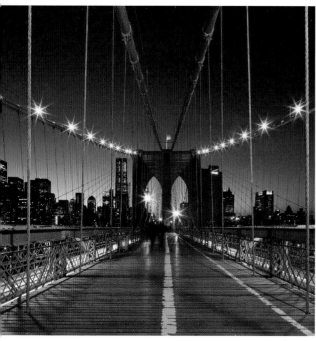

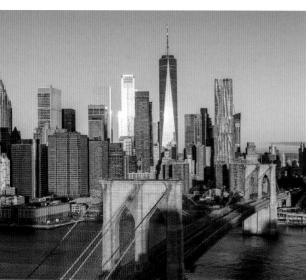

LEFT The bridge's pedestrian walkway at night.

BOTTOM LEFT The Brooklyn Bridge has inspired generations of writers and artists.

BROOKLYN BRIDGE

CENTRE STREET AND CHAMBERS STREET IN LOWER MANHATTAN, AND TILLARY STREET AND ADAMS STREET IN BROOKLYN

Completed in 1883, Brooklyn Bridge is an engineering marvel linking Manhattan and Brooklyn, and took thirteen years to build. Since then, millions of visitors have crossed in cars and on foot, and it has inspired photographers, painters, and writers. American Modernist poet Hart Crane was inspired by the Brooklyn Bridge as a physical structure and an achievement of engineering and artistry. It's a central motif in his epic poem 'The Bridge', which explores the American identity and the need for connection. Alan Ginsberg included the poem 'Brooklyn Bridge Blues' in his 1954 collection *Empty Mirror: Early Poems*, comparing the structure to Stonehenge, and giving it a sense of mystery and mysticism that transcends the physical structure. In Paul Auster's 1985 novel *City of Glass*, protagonist Daniel Quinn becomes obsessed with the bridge, and Auster uses the location and Quinn's walks along it to blur the lines between reality and illusion, and sanity and madness. The bridge is also included in John Dos Passos' *U.S.A.* trilogy, and in Jack Kerouac's *On the Road*. The bridge is accessible from both the Brooklyn and Manhattan sides. It has dedicated pedestrian and bike lanes, and there are vendors and street performers, too.

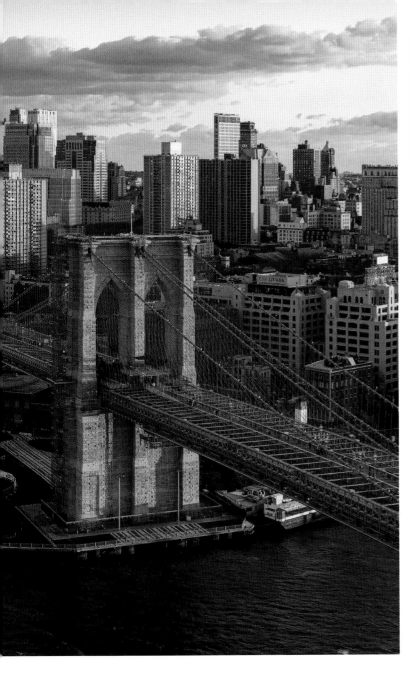

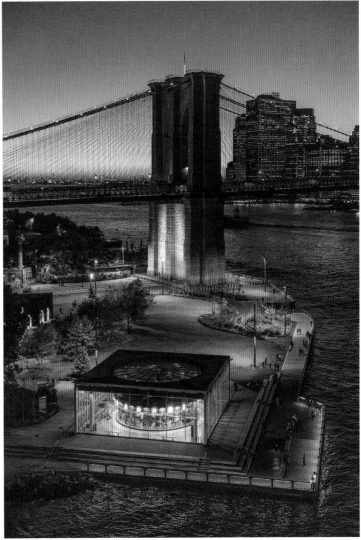

LEFT Views towards Brooklyn showing its evolving skyline.

ABOVE Jane's Carousel under the bridge in Brooklyn, a restored antique carousel in a glass enclosure designed by star architect Jean Nouvel.

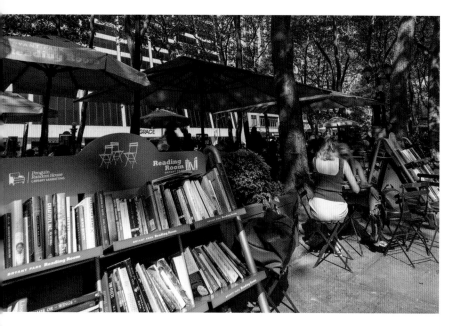

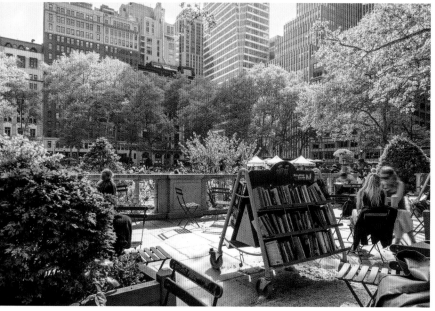

LEFT Books galore in this literary meeting place.

BOTTOM LEFT A peaceful spot amid the bustle of New York City.

RIGHT The space has hosted many events and readings from well-known writers.

THE READING ROOM AT BRYANT PARK

WEST 42ND STREET AND 5TH AVENUE

The Reading Room at Bryant Park is an outdoor gathering place located between Fifth and Sixth Avenue in Manhattan, adjacent to the main New York Public Library (see p53). Bryant Park was originally dedicated as a public space in 1686, and over the years has undergone multiple changes and renovations, including the most notable one by Frederick Law Olmsted, the landscape architect who designed Central Park. The Reading Room began to take shape in the early 2000s to help bring New Yorkers and visitors back to the park. Officially opened in 2003, it provides free access to books and magazines, along with tables and chairs for reading or working in nature during the warmer months of the year. The Reading Room hosts a number of events throughout the season, including storytime for kids, writing workshops for teens, 'Books on Broadway' (which features the cast and crew of books that are on Broadway), and readings featuring emerging and established authors. Toni Morrison, Junot Diaz, Margaret Atwood, Elizabeth Gilbert, Stephen King, and Neil Gaiman are only a few of the authors who have appeared over the years. New events are planned seasonally.

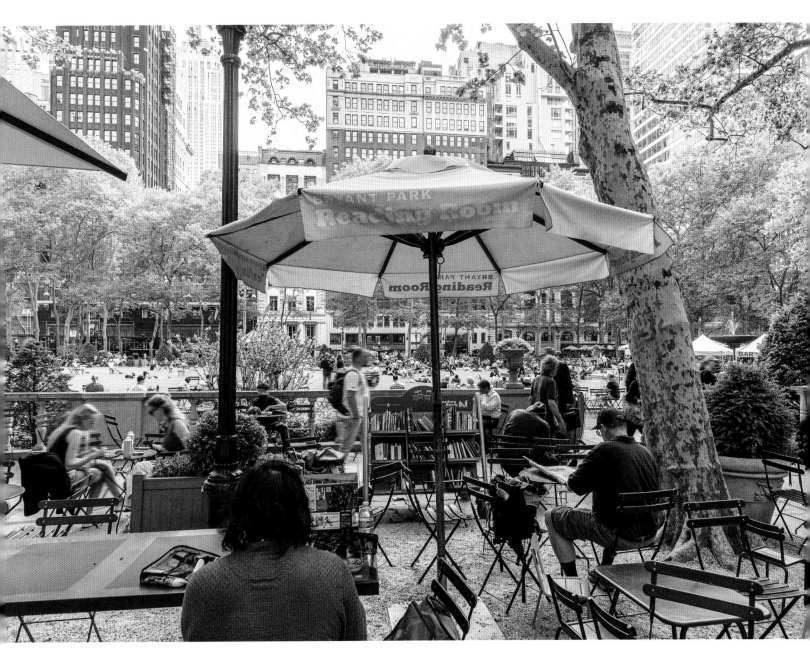

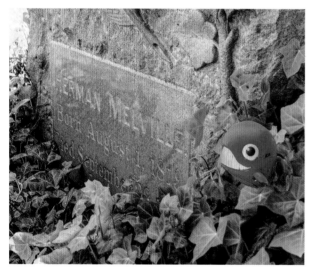

TOP Melville's gravestone, where visitors leave pens on top in his honor. .

ABOVE Herman Melville's gravestone is adorned with a whale in reference to his most famous book, *Moby Dick*.

RIGHT Woodlawn Cemetery was declared a National Historic Landmark.

RIGHT Dorothy Parker's gravestone.

BOTTOM RIGHT E. L. Doctorow's gravestone sits in afternoon sun.

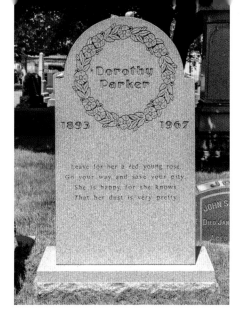

WOODLAWN CEMETERY

4199 WEBSTER AVENUE (BRONX)

Woodlawn Cemetery is located in the Woodland Hills section of the Bronx, which was bucolic and rural when it was founded in 1863. Founded by a group of investors led by Benjamin W. Wainwright, the cemetery houses the remains of 310,000 individuals, including famous captains of industry, artists, judges, politicians, and writers, including Herman Melville, Nellie Bly, Clarence Day, E.L. Doctorow, and Dorothy Parker. The leafy setting envelopes many unique and dramatic memorials built by notable American architects, including McKim, Mead & White, Carrère and Hastings, John Russell Pope, and others. Today, the cemetery is protected by The Woodlawn Conservancy, an organization dedicated to preserving graves, as well as the collections of local plants and trees that provide a park-like home to the many insects and birds that have few places to thrive in the now-urban neighbourhood. Daily tours and educational opportunities are available for visitors who want to pay respects to those who rest there, or plan for their own burial among the rolling hills.

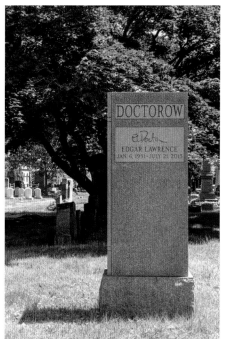

RIGHT The grave of Alexander Hamilton.

BOTTOM RIGHT A statue of John Watts Jr. takes centre stage in the graveyard.

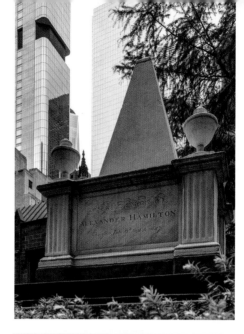

TRINITY CHURCHYARD

74 TRINITY PLACE

Trinity Churchyard at Broadway and Wall Street is adjacent to Trinity Church, which is the third building to be constructed after the first two were destroyed by fire and weakened by snow. It was established as a burial ground in the late seventeenth century in Lower Manhattan, and became a resting place for many important historical figures and writers. Alexander Hamilton – one of the country's Founding Fathers, subject of *Hamilton* the musical and author of *The Federalist Papers* – is buried here with his wife Eliza Schuyler Hamilton and their son Philip, along with many others who helped shape the early days of America and New York City. Notable graves include Richard Churcher, a poet and author who died in 1723 (one of the oldest inscriptions in the cemetery); Dr. Benjamin Moore, an Episcopal bishop who wrote a sermon eulogizing President George Washington after his death; and William Bradford, a printer and publisher who established the first printing press in New York in 1693. In addition to historical figures, gravestones in Trinity Churchyard include one for Charlotte Temple: the heroine of the novel *A Tale of Truth* by Susanna Rowson. In other literary connections, Trinity Churchyard is mentioned in Henry James's novella *Washington Square*, and is also referenced in Washington Irving's essay 'Westminster Abbey' in *The Sketch Book of Geoffrey Crayon*, Gent. Both authors reference the tranquillity of the graveyard in the middle of the chaos of Lower Manhattan, where it still remains a spot for peace and reflection.

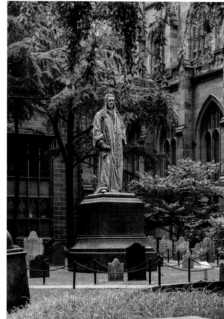

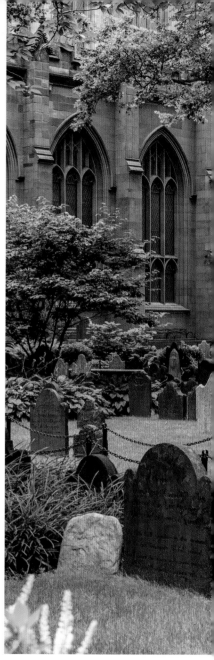

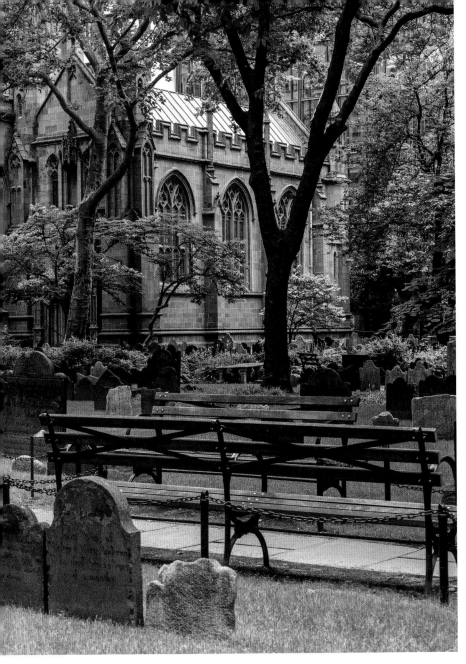

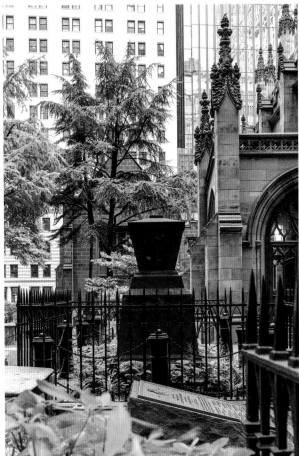

ABOVE AND LEFT The churchyard is known for its tranquillity within the busy city.

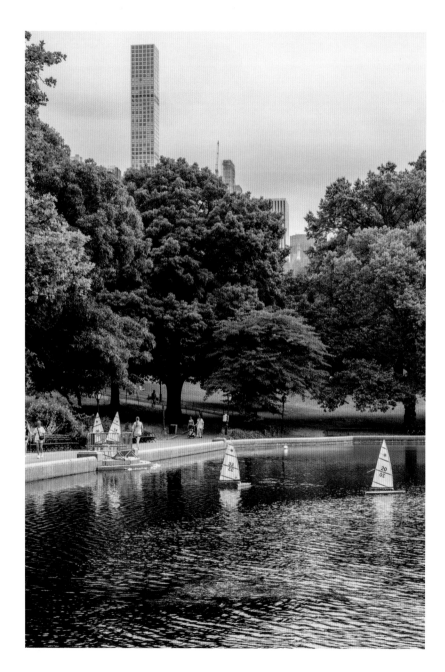

CONSERVATORY WATER

CENTRAL PARK (AT 5ᵀᴴ AVENUE AND EAST 74ᵀᴴ STREET)

Conservatory Water, sometimes known as Conservatory Pond, in Central Park was built as a reflecting pool in the late nineteenth century by Frederick Law Olmsted and Calvert Vaux, the landscape architects who designed Central Park. It draws water from the Ramble and Lake, another Central Park water feature, and uses a natural hollow for its basin. The Kerbs Memorial Boathouse, designed by architect Aymar Embury II, rents radio-controlled model boats that visitors can sail on the pond like Stuart Little in E.B. White's renowned children's book from 1945. Stuart Little is a mouse who lives with a human family on the East Side in New York City. On one of his many adventures, he heads to Central Park and convinces the owner of the Wasp, a boat that sails on the pond, to let him sail the craft in a race against another boat, the Lillian B. Womrath. Because of his small size, he can actually ride in the boat, controlling the sails and the speed in a way the captain of the Lillian cannot. In spite of many challenges, including a rogue wave that knocks the mouse into the water, Stuart wins the race. And White wins at sharing his love for Central Park and the magic of the stories it inspires.

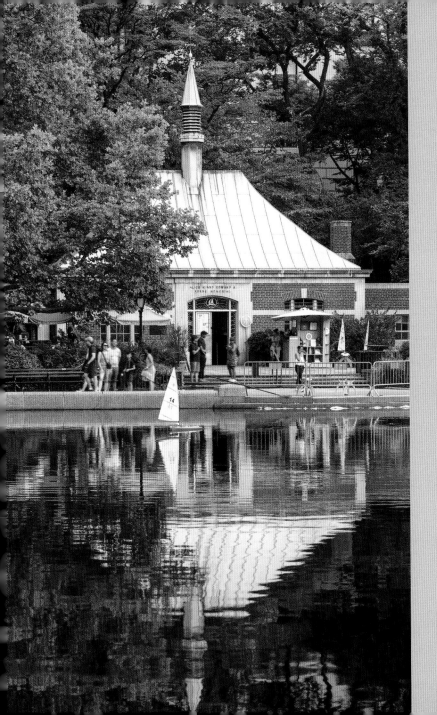

"

Central Park is the grandiose symbol of the front yard each child in New York hasn't got.

ROBERT BENCHLEY

LITERARY WALK

CENTRAL PARK (BETWEEN 66ᵀᴴ STREET AND 74ᵀᴴ STREET)

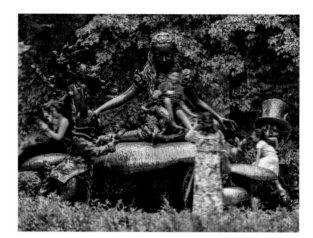

Among the many statues in Central Park, there is a path along the main Promenade called the Literary Walk. Stretching between 66th and 72nd Streets, it features four statues of renowned writers, designed and installed between 1872 and 1880. Visitors can find bronze representations of William Shakespeare (designed by John Quincy Adams Ward and installed in 1872), Scottish poet Sir Walter Scott (designed by Sir John Steell), Scottish novelist Robert Burns (installed in 1880 and also designed by Sir John Steell), and Fitz-Greene Halleck (designed by James Wilson Alexander MacDonald and installed in 1877).

A little to the north of the Promenade and Conservatory Water (see p132), there are additional literary statues representing beloved children's books. Near the Conservatory Garden and East 74th Street is an 3.5-metre- (11-feet-) tall scene from Lewis Carroll's *Alice in Wonderland*, featuring Alice, the Mad Hatter, and the White Rabbit, all gathered on a large mushroom. Created by sculptor José de Creeft, generations of children have climbed the larger-than-life statue since it was installed in 1959.

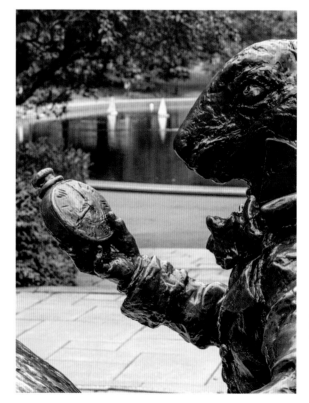

Near the Alice statue is a bronze depiction of Hans Christian Andersen reading his story *The Ugly Duckling* to a duckling, commissioned to celebrate his 150th birthday. Since 1957, Georg Lober's statue has silently presided over outdoor story time, organized by The Hans Christian Andersen Storytelling Center on Saturdays in the summer.

At the end of a water lily pool in the Conservatory Garden is The Burnett Fountain, featuring Mary and Dickon, two characters from Frances Hodgson Burnett's *The Secret Garden*. Friends of the author commissioned the sculpture from Bessie Potter Vonnoh in 1927, but it sat in storage until the Conservatory Garden opened in 1937.

While the many literary sculptures in Central Park were commissioned at different times, they come together to represent some of the best public art in Manhattan.

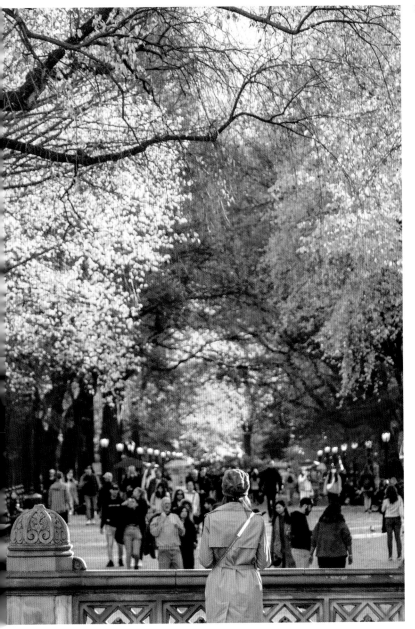

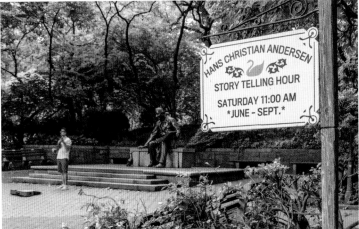

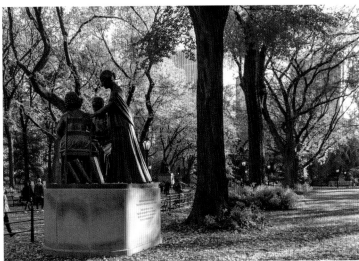

TOP LEFT The statue's scene from *Alice in Wonderland* is hugely popular with children.

BOTTOM LEFT The White Rabbit checks his pocket watch.

LEFT Literary Walk is at the south end of the Promenade.

ABOVE The Women's Rights Pioneers monument.

TOP Outdoor storytime has been held here since 1957.

> "
>
> I just want to go through Central Park and watch folks passing by. Spend the whole day watching people. I miss that.
>
> **BARACK OBAMA**

THE BETHESDA FOUNTAIN
CENTRAL PARK (AT 72ND STREET)

The Bethesda Fountain was always a part of Frederick Law Olmsted and Calvert Vaux's original layout for Central Park, to commemorate the completion of the Croton Aqueduct, which brought fresh water to the city. The iconic 'Angels on the Water' statue, created by lesbian sculptor and wildly successful artist Emma Stebbins, serves as its centrepiece, and was the first public art commission in NYC to be given to a woman in 1868. It is heavily inspired by a Bible passage in *The Gospel of John*, where an angel blessed the Bethesda Fountain and gave it the power to heal. Bethesda Fountain and the statue feature prominently in Tony Kushner's 1991 play *Angels In America*, as both a meeting place for characters, as well as symbols of the powers of healing and renewal, which are represented throughout the work. Similarly, Central Park and the Croton Aqueduct represent the healing powers that running water and fresh air brought to the citizens of New York.

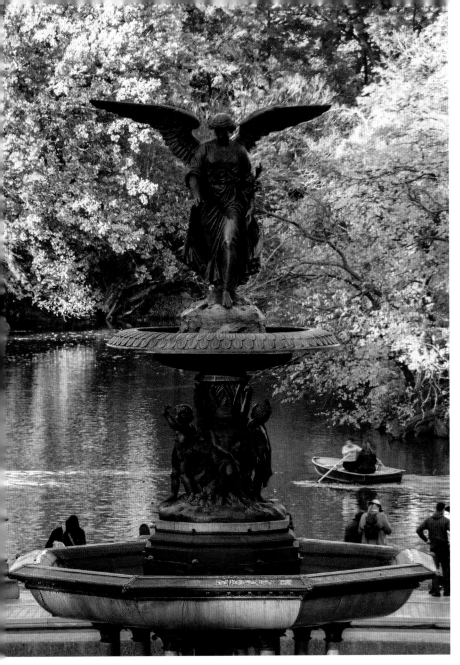

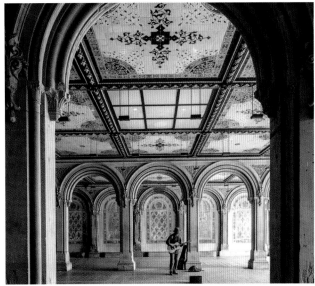

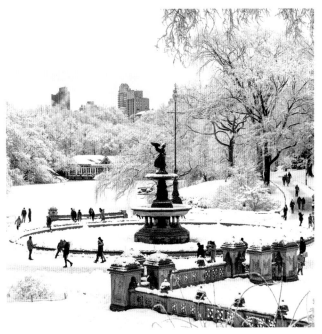

JOHN DOS PASSOS' NEW YORK

FROM MANHATTAN TRANSFER & U.S.A

John Dos Passos' time in New York City shaped the texture and detail of his work, influencing a whole generation of authors and stories about life in the big city. He lived between Brooklyn and Manhattan in the 1920s and 1930s, where he was considered a member of the Lost Generation of writers, including E.E. Cummings, F. Scott Fitzgerald, Edna St. Vincent Millay, and Henry Miller, to name a few. These writers all spent time living in New York City with Dos Passos. They came of age before World War One and published significant works in the 1920s. John Dos Passos published *Manhattan Transfer* and his *U.S.A.* trilogy during that time of significant social and cultural upheaval. His writings were often non-linear, exploring themes of social justice and the human condition. His texts visit Manhattan and Brooklyn; especially to the places where conflicts between the wealthy and the struggling take place below the surface. In *Manhattan Transfer*, Dos Passos takes readers from the Battery Park waterfront to the Brooklyn Heights promenade and a tragic scene on the Brooklyn Bridge. All of the locations highlight the tension of modern life, and the changes and challenges faced by city dwellers between the worlds. Today, many of these locations are gentrified, but the original architecture and locations illustrate the conflicts of gentrification and progress on those who were struggling to live the American dream.

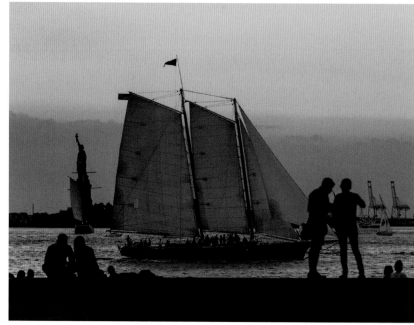

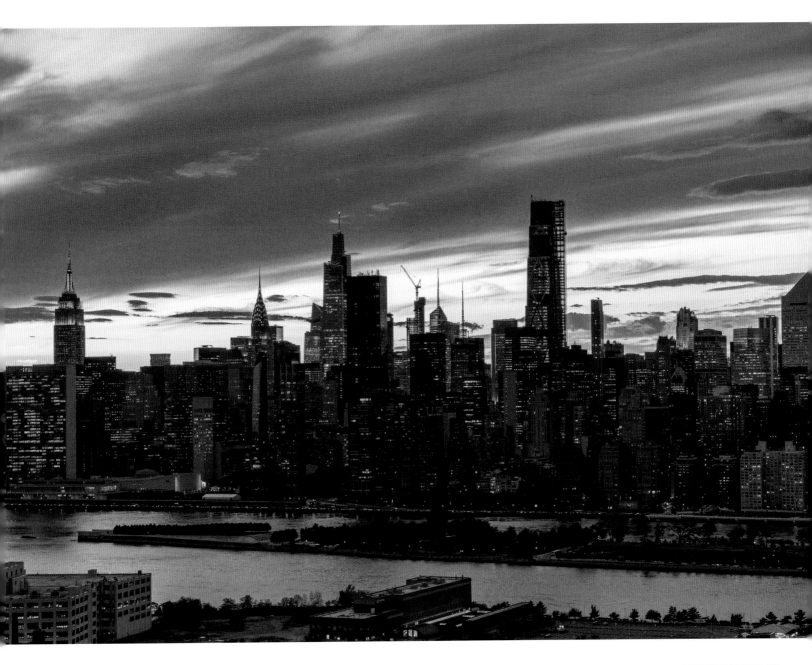

LEFT The Bronx County Courthouse is a historic Art Deco structure.

TOP RIGHT The Charging Bull statue by Arturo Di Monica is a symbol of Wall Street greed. It was created as a response to the perceived excesses of the 1980s that also inspired Wolfe's novel.

BOTTOM RIGHT Park Avenue became the ultimate luxury address because of its equidistance from the gritty waterfronts on both sides of Manhattan. Thousands of tulips bloom there every spring.

TOM WOLFE'S NEW YORK

FROM THE BONFIRE OF THE VANITIES

Tom Wolfe's satire *The Bonfire of the Vanities* takes readers on an epic tour of 1980s New York. Wolfe follows main character Sherman McCoy from a crime scene in a gritty South Bronx neighbourhood to a multimillion-dollar Park Avenue penthouse, to his job on Wall Street, and to luxury restaurants, including the 21 Club (see p78) and Windows on the World. In this way, Wolfe juxtaposes the danger of the opening scene with the luxury surrounding the rest of McCoy's life. In an homage to Charles Dickens, Wolfe initially published the book bi-monthly, serialized in issues of *Rolling Stone*, before editing it heavily and releasing it in novel form in 1987. It was an immediate critical and commercial success. While the South Bronx has gentrified, and most of the restaurants McCoy visited have closed, its sharp exploration of social justice and equity were as relevant in the 1980s as they are now.

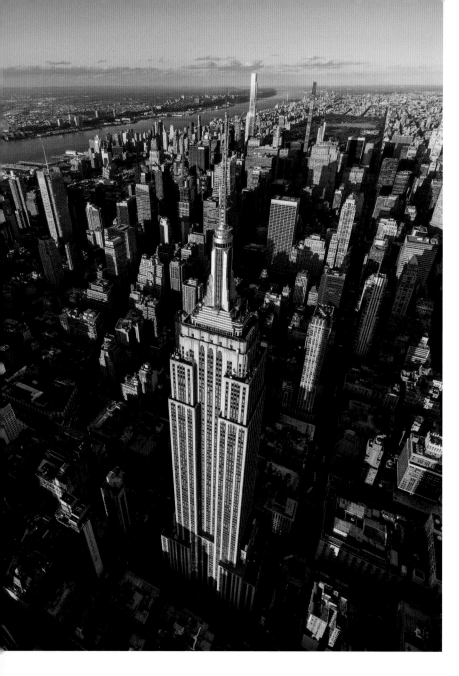

SYLVIA PLATH'S NEW YORK

FROM THE BELL JAR

Sylvia Plath wrote only a single novel before succumbing to the mental illness she described in that same book. *The Bell Jar* told the story of Esther, a Massachusetts girl who sets off for a summer internship at a magazine in New York. While working should have been exciting, Esther feels depressed and unexcited about the opportunities afforded to her and the people she meets. Plath takes readers on a journey through the city in 1953, to places including a midtown magazine office, the Empire State Building, and Radio City Music Hall. Esther's inner turmoil in the pages of the book closely resembled Plath's, who returned home to Massachusetts after an internship with *Mademoiselle* magazine, and sought treatment for the mental health concerns that had begun in Manhattan. Plath took her own life in 1963, one month after *The Bell Jar* was released in the UK under Plath's pseudonym Victoria Lucas, and ten years after her first documented attempt. In the years in-between, she struggled with her demons, she married fellow poet Ted Hughes, and published a collection of poetry in 1960 called *The Colossus and other Poems*. Her second poetry collection *Ariel,* was released after her death in 1965. *The Bell Jar* was finally attributed to Plath in 1967, and was eventually released in the US in 1971. Though the book was almost twenty years old by that time, Esther's struggles with gender roles, the frustration she felt for the expectations of women in society, and her struggles with the mental health treatments she desperately needed still resonated. Plath's *The Collected Poems* was published in 1981. It included new works and earned her a Pulitzer Prize for poetry.

LEFT The Empire State Building from above.

ABOVE Radio City Music Hall is a hive of activity in a buzzing city, especially during the winter holidays.

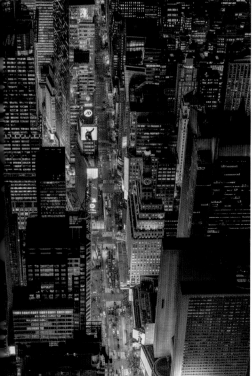

LEFT A private garden in the exclusive Sutton Place neighbourhood.

BELOW LEFT An aerial view of Times Square at night.

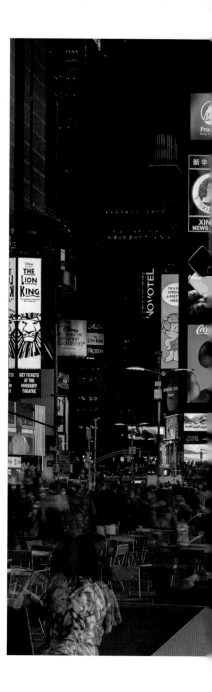

IRA LEVIN'S NEW YORK

FROM A KISS BEFORE DYING

Ira Levin was born in New York in 1929 and lived there most of his life until he passed away in 2007. He was famous for books that explored the darker aspects of human nature. Paranoia and manipulation feature frequently in his novels, including *Rosemary's Baby*, *The Stepford Wives* and *The Boys from Brazil*. His first novel, *A Kiss Before Dying*, was published in 1953 and won the Edgar Award for Best First Novel in 1954. The psychological thriller tells the story of Burton 'Bud' Corliss, a man so obsessed with gaining wealth and social standing in 1950s New York that he's willing to kill for it. The novel is lauded for its unique narrative structure, its study of the psychopathic mind, and the version of 1950s Manhattan that Levin depicts in-between Bud's time in the Korean war and his move to Iowa.

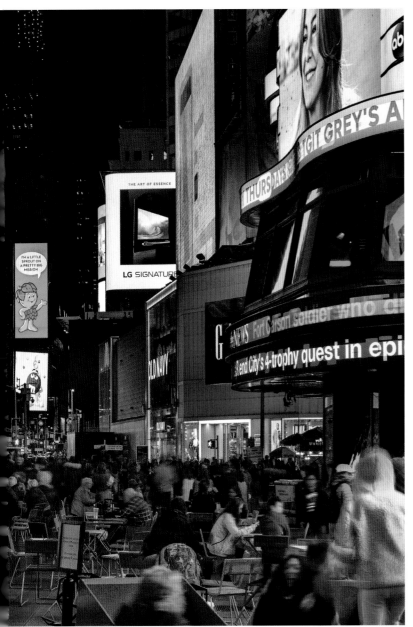

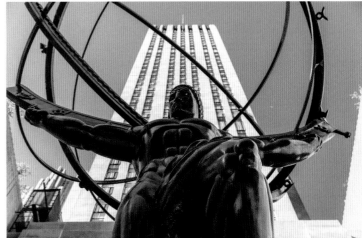

LEFT Bustling Times Square by night.

TOP Museum of Modern Art.

ABOVE The Atlas statue sits at Rockefeller Centre.

I regret profoundly that I was not an American and not born in Greenwich Village. It might be dying, and there might be a lot of dirt in the air you breathe, but this is where it's happening.

JOHN LENNON

By comparison with other less hectic days, the city is uncomfortable and inconvenient; but New Yorkers temperamentally do not crave comfort and convenience—if they did they would live elsewhere.

E.B. WHITE

AUTHOR HOMES & TOURS

INSPIRED BY BOOKS

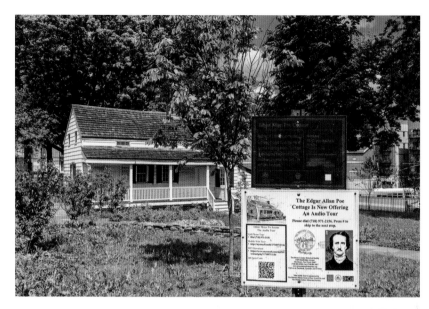

THE POE COTTAGE

2640 GRAND CONCOURSE (BRONX)

Edgar Allan Poe moved from Baltimore to New York in 1837, calling various haunts in Greenwich Village and the Upper West Side home while writing for local publications, including the *New York Evening Mirror* and the *Broadway Journal*. In journalistic style, he based *The Mystery of Marie Rogêt*, published in 1842, on a real-life Manhattan murder. Full of gritty details of life in NYC, as well as facts from the unsolved case, it is considered one of the earliest examples of the American detective novel. The last home of Edgar Allen Poe was Poe Cottage in the Bronx, where he lived from 1846 until his death in 1849. It was a pivotal if not bittersweet place in terms of personal and literary landmarks: here, he lost his wife Virginia after eleven years of marriage, and went on to write *The Bells* and *Annabel Lee*, which was inspired by his late wife. Today, Poe Cottage has been preserved as a museum and is maintained by the Bronx County Historical Society, which honours Poe's life and work.

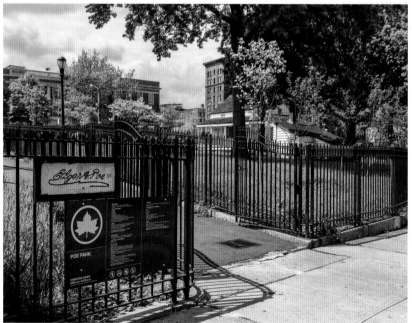

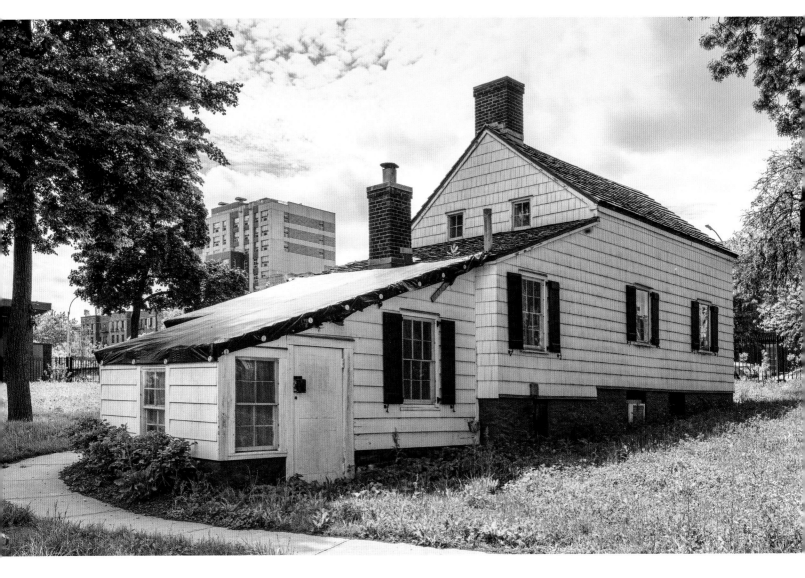

TOP LEFT Poe Cottage has been run as a museum since 1975.

BOTTOM LEFT The cottage is situated in Poe Park in the Bronx.

ABOVE Built around 1812, this site is a New York City and State landmark.

MARK TWAIN'S RESIDENCE

14 WEST 10TH STREET

Mark Twain made his home in New York many times over the course of his life and writing career. The Mark Twain House, where he wrote his autobiography and lived from 1904 to 1908 was at twenty-one 5th Avenue in Greenwich Village. Unfortunately that structure was demolished in 1954. Before that, however, he lived at fourteenth West 10th Street, a storeyed structure that features in a number of NYC ghost tours, as it is said to be haunted by no less than twenty ghosts (some of which were already there when Twain stayed in 1901). While living in and visiting New York, he spent time staying, eating, drinking, and lecturing at The Players club in Gramercy Park, which he co-founded. He lectured at Carnegie Hall and Cooper Union, and ate and drank at Delmonico's (see p89) and Pfaff's Beer Cellar. It is said he is one of the ghosts that people have seen at the house on West 10th Street. Visit if you dare.

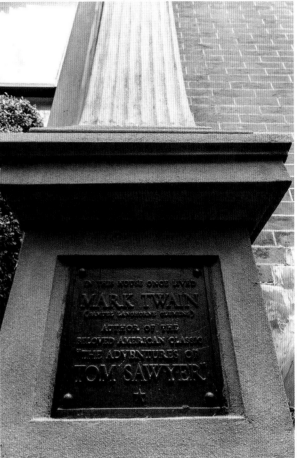

LEFT The house is known locally as 'Number 14'.

ABOVE A plaque dedicated to Mark Twain awaits by the door.

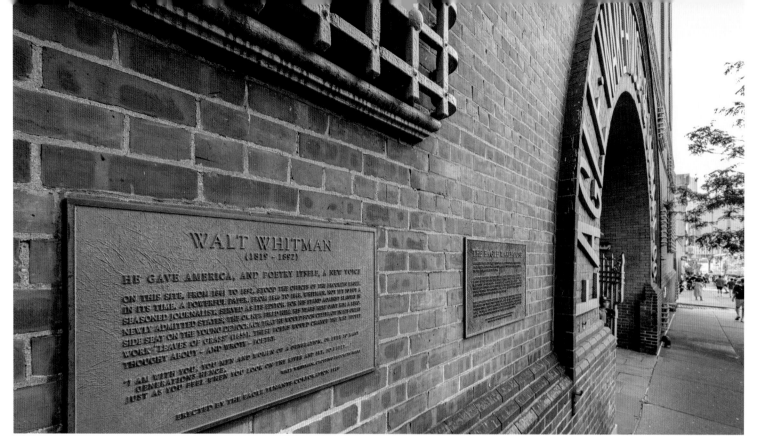

WALT WHITMAN
(1819 – 1892)

HE GAVE AMERICA, AND POETRY ITSELF, A NEW VOICE

ON THIS SITE, FROM 1841 TO 1892, STOOD THE OFFICES OF THE BROOKLYN EAGLE.
IN ITS TIME, A POWERFUL PAPER. FROM 1846 TO 1848, WHITMAN, NOT YET MERELY A
SEASONED JOURNALIST, SERVED AS ITS EDITOR. FOR HIS STAND AGAINST SLAVERY IN
NEWLY ADMITTED STATES, THE OLDER FREED HIM. HIS YEARS HERE GAVE HIM A FIRST-
SIDE SEAT ON THE YOUNG DEMOCRACY THAT HE WOULD SOON CELEBRATE IN HIS GREAT
WORK "LEAVES OF GRASS" (1855). THESE POEMS WOULD CHANGE THE WAY PEOPLE
THOUGHT ABOUT – AND WROTE – POETRY.

"I AM WITH YOU, YOU MEN AND WOMEN OF A GENERATION, OR EVER SO MANY
GENERATIONS HENCE,
JUST AS YOU FEEL WHEN YOU LOOK ON THE RIVER AND SKY, SO I FELT"

WALT WHITMAN, CROSSING BROOKLYN FERRY

ERECTED BY THE EAGLE MARINE CORPORATION 1976

ABOVE Eagle Warehouse & Storage
Company, now converted to luxury housing.

RIGHT The eagle from the old Brooklyn
Eagle building has been relocated to the
front doors of the Brooklyn Public Library.

WALT WHITMAN'S BROOKLYN

99 RYERSON, BROOKLYN EAGLE ON FULTON, THE FERRY AT PIER ONE

Walt Whitman was born in West Hills in the town of Huntington, Long Island, on May 13 1819 and moved with his parents to Brooklyn when he was four. He left school at age eleven to help support his family, finding a myriad of literary jobs that included working as a printer's assistant for *The Patriot Newsletter*, a librarian for the Brooklyn Apprentice Library, and as an editor for the *Brooklyn Eagle* and many other local papers. Whitman published articles, cultural reviews, freelance fiction, and poetry before self-publishing the first edition of *Leaves of Grass* in 1855 while living at 99 Ryerson Street in Clinton Hill.

In 1954, the City of New York carved out a small urban park in Cadman Plaza and named it after the author to celebrate one hundred years of the poetry collection that supercharged his career. The *Brooklyn Eagle* offices were at 28 Old Fulton Street in Brooklyn Heights, just a short walk away. While the specifics of the boat and the skyline are different to when Whitman wrote the words, those that cross the river today remain the audience he wrote the poem for.

> **"**
>
> New York is a diamond iceberg floating in river water.
>
> **TRUMAN CAPOTE**

TRUMAN CAPOTE'S RESIDENCE
70 WILLOW STREET (BROOKLYN)

Truman Capote lived and wrote at 70 Willow Street in Brooklyn from 1955 to 1965, a place he rented from Broadway stage designer Oliver Smith. The home was one of the largest townhouses on a picturesque tree-lined street that inspired Capote's personal essay *Brooklyn Heights: A Personal Memoir*, about the home and the people and places he loved nearby. It's rumoured that he rented the basement, but often showed off the whole house and claimed it as his own when visited by other writers and artists, including Harper Lee, Tennessee Williams, Joan Didion, and Andy Warhol. While Capote eventually moved back to the other side of the East River, he wrote *In Cold Blood* and *Breakfast at Tiffany's* while living on Willow Street.

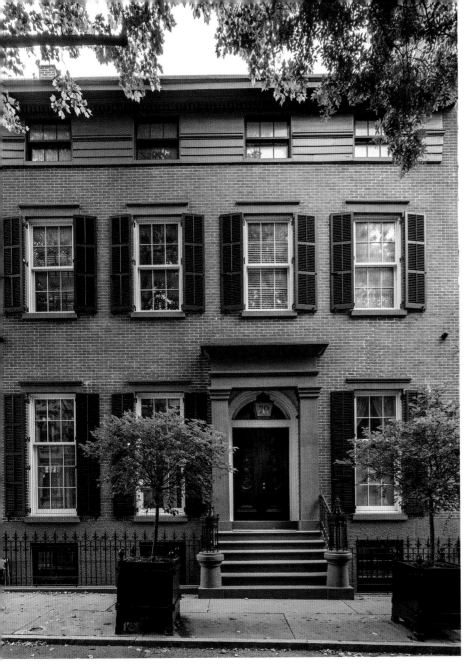

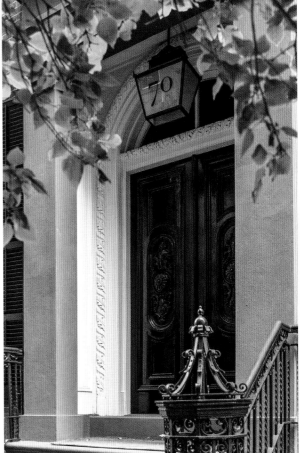

LEFT The large Greek Revival townhouse in Brooklyn Heights.

ABOVE Number 70 hangs grandly above the door.

JAMES BALDWIN RESIDENCE

137 WEST 71ST STREET

James Baldwin was born and raised in Harlem, and lived at 81 Horatio Street in Greenwich Village before moving to 137 West 71st Street, where he kept a residence until his death. It's said Toni Morrison also stayed there for a time. Baldwin was indeed a 'Native Son of New York', and his writings reflected the challenges faced by African Americans in the 1950s. Though he travelled through the city, his roots and his writings take place in many locations throughout Harlem. Growing up, he attended school in Harlem at Frederick Douglass Middle School, where he edited the school paper. He spent many afternoons each week at the Harlem branch of the public library on West 135th Street. Though he lived in numerous locations in Greenwich Village and then on the Upper West Side, the Harlem of his youth influenced much of his writings. In *Go tell It On The Mountain*, he mentions 125th Street, which is the commercial hub of Harlem. In *Another Country*, he talks about Strivers' Row, on West 138th and 139th Streets between Adam Clayton Powell Jr. Boulevard and Frederick Douglass Boulevard, where wealthy African Americans lived. His writing resonated with many other marginalized communities who also struggled with race, identity, and belonging in mid-twentieth-century New York, but his Harlem birthplace is a through-line to the African American community that lived there then and still lives there now.

Pavilion
An imprint of HarperCollinsPublishers Ltd
1 London Bridge Street
London SE1 9GF

www.harpercollins.co.uk

HarperCollinsPublishers
Macken House, 39/40 Mayor Street Upper
Dublin 1, D01 C9W8, Ireland

10 9 8 7 6 5 4 3 2 1

First published in Great Britain by
Pavilion, an imprint of HarperCollinsPublishers Ltd 2025

ISBN 978-1-911-663-027

This book is produced from independently certified FSC™ paper to ensure responsible forest management.

For more information visit: www.harpercollins.co.uk/green

Printed and bound in Malaysia by Papercraft

Publishing Director: Laura Russell
Commissioning Editor: Ellen Simmons
Designer: Lily Wilson
Artworker: Cara Rogers
Copy editor: Kate Reeves-Brown
Proofreader: Molly Price
Production controller: Grace O'Byrne